Window Gardens

in Bloom

25 Hand-Embroidered Flowers in Easy-to-Create Settings

Margaret Vant Erve

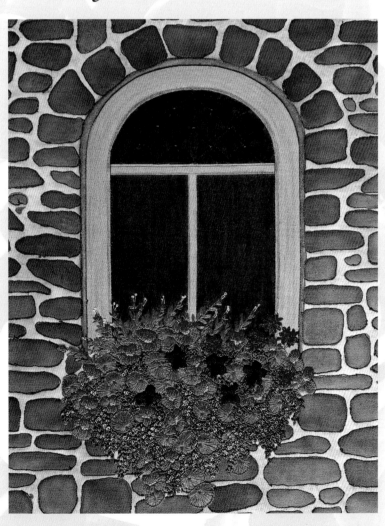

C&T PUBLISHING

Text and artwork © 2005 Margaret Vant Erve
Photography © 2005 C&T Publishing, Inc.

Publisher: Amy Marson
Editorial Director: Gailen Runge
Acquisitions Editor: Jan Grigsby
Editor: Cyndy Lyle Rymer
Technical Editor: Teresa Stroin
Copyeditor/Proofreader: Wordfirm Inc.
Cover Designer: Christina D. Jarumay
Design Director/Book Designer: Christina D. Jarumay
Production Assistant/Illustrator: Tim Manibusan
Photography: Diane Pedersen and Luke Mulks unless oth-
erwise noted; flower photos by Cyndy Lyle Rymer
Published by C&T Publishing, Inc., P.O. Box 1456,
Lafayette, CA 94549

Library of Congress Cataloging-in-Publication Data
Vant Erve, Margaret Henrietta
 Window gardens in bloom : 25 hand-embroidered flowers
in easy-to-create settings / Margaret Vant Erve.
 p. cm.
 Includes bibliographical references and index.
 ISBN 1-57120-306-0 (paper trade)
 1. Embroidery–Patterns. 2. Flowers in art. 3. Textile
painting. I. Title.

TT773.V36 2005
746.44'041–dc22

 2005006459

Printed in China
10 9 8 7 6 5 4 3 2 1

Dedication

In memory of my dear friend Charlie
Barker, who loved all things beautiful,
especially flowers.

Acknowledgments

My heartfelt thanks go out to many people who
assisted and encouraged me in writing this book.
To my husband, Stephen Hayward, I thank you for
your constant support and for being such a positive
person. To my daughters, Emily and Julia Hart, you are
the joy in my life. To Marie Tremble, who was always
there to proofread, edit, and make sure everything
was clear; I could not have done this without you. To
Debra Lyall, my framer and constant fan. To Shirley-
Mae Collis, my teacher and friend. To the wonderful
editors at C&T, for your belief in me, especially to
Cyndy Rymer, Diane Pedersen, Jan Grigsby, and
Teresa Stroin for your cheerful guidance and support,
and to Luke Mulks, Christina Jarumay, and Tim
Manibusan for your hard work and artistry. Finally, to
all my family, friends, patrons, and embroidery guild
members who have liked looking at my embroideries,
enjoyed attending my classes, and continue to
encourage me in my endeavors.

Contents

Introduction

Window boxes earn pride of place in the city, where they expand a gardener's canvas and, in some cases, provide the only sunny spot for nurturing favorite plants. As a child growing up on a farm in rural Ontario (Canada), I spent countless hours tending our vegetable gardens and many more hours in the barn with the animals. Although I now live in the city, my rural roots have never left me. My artwork alternates between rural and urban landscapes simply because I love them both! My gardening, however, is strictly city as I try to squeeze annuals, perennials, and bulbs in every corner of the garden and every available planter.

I attended art school at a time when embroidery wasn't part of the curriculum and a "serious artist" was encouraged to study fine arts. Undaunted, I studied textile art and cast about for my own training in embroidery. Fortunately, I found One Stitch at a Time, a nearby embroidery shop whose name suited my pace. A whole new world of fabric, thread, and color opened up for me when I walked through those doors. However, feeling somewhat overwhelmed and a bit shy, I walked out empty handed. I went to a larger department store where, feeling less conspicuous, I purchased several colors of stranded floss and a remnant of fabric and rushed home to stitch up a pansy. My masterpiece was stitched by hand using six strands of floss and an old needle. The next day, I marched

down to the shop and proudly showed off my work. I'll never forget the owner's smile and her gentle manner as she patted me on the shoulder and said: "Why don't you come and take a class, Margaret?" What followed were two years of extensive training in the fine art of embroidery—all under Ann Adam's patient and knowledgeable tutelage. She allowed me to struggle with my own designs and, of course, learn by my mistakes. I came away from the experience with a love of embroidery and a fastidious approach to technique. I've been stitching, drawing, and, of course, gardening to this day.

Although I have taught embroidered landscapes for many years, I was keenly aware that many embroiderers were not quite ready to give up kits and tackle a landscape. So I designed an "Embroidered Gardens Under Windows" course after endless experimentation with crayons, paints, appliqué methods, and embroidery techniques. The course was received enthusiastically and I have been teaching it ever since, using every class as an opportunity to iron out details and fine-tune the design. The results are the projects and instructions offered to you in this book.

I hope you will take the time to read through *Window Gardens in Bloom* and create your own painted and embroidered window garden. If you come away from the experience a bit wiser in your approach to fabric painting and embroidery or inspired to try new techniques and designs, my work will be complete. Maybe the next time you walk into your favorite embroidery shop, you, too, can show off your original masterpiece.

Flower GALLERY

The following pages offer instruction for 27 common flowers that are appropriate for window boxes. Although these flowers were created for the window garden projects that follow, they also make a beautiful sampler and can be used individually or collectively to decorate a myriad of items. Experiment and create a sampler for future reference, and above all, have fun.

The creation of each embroidered flower was done with a great deal of observation and trial and error. It is enormously pleasing to create these flowers in stitches. I hope that in experimenting with them, you will be inspired to try your own interpretations.

The colors suggested throughout the book have been matched carefully to the plant to achieve a realistic effect. Some plants, such as pansies, come in a multitude of colors; for these, I do not note a specific color to use. For others, such as alyssum or salvia, the color choice is more limited, so I have given the specific floss numbers. However, colors are never definitive. Light and location have an enormous effect on the color of a plant. Experiment with blending colors in the needle to achieve subtle effects. The photographs and illustrations of each flower are reproduced in actual size, which will help you achieve the correct scale for the projects in this book.

The alphabetized Stitch Directory beginning on page 47 provides detailed instructions for all the stiches mentioned in this Flower Gallery. Also, read Starting and Finishing a Thread on page 47. Remember whether you are embroidering an individual flower or creating a sampler, your fabric must always be stretched either in an embroidery hoop or in a frame.

Transferring Details

Some flowers and leaves will need to be drawn onto the fabric first. When indicated, use either a sharp pencil, applied lightly, or a water-soluble fabric marker. I prefer a Tailor fabric marker. The ink can be removed with a damp cloth as soon as the flowers are completed. Pencil does not remove, so it is essential that any pencil marks be done lightly and be completely covered with stitches.

Begin by drawing the large flower heads and prominent leaves. Next, draw in the outline of larger leaves, such as the geranium and dahlia, and flowers with a specific shape, such as the pansy. When necessary, more specific instructions are included with the individual flowers.

> If you use a water-soluble fabric marker, test it on a scrap of cotton first. The marker should disappear with the application of a damp rag in the marked area. You should not have to wash the fabric.

General Supplies

NEEDLES

Crewel needles are best for this type of embroidery. They have a sharp point and a large eye, making them easy to work with. Choose a needle that is easy to thread and that makes a hole in the fabric that is sufficient for the thread to pass through. While a small needle will keep your work fine, if it is too small for the thread, you will find it difficult to pull the thread through the fabric, especially through fused fabric. I suggest you use these needles:

- Number 9 crewel for one strand of floss
- Number 8 crewel for two strands of floss
- Number 7 crewel for three strands of floss

THREAD

DMC flosses come in six strands gently twisted together. To separate individual strands of thread, hold the cut thread at the top, and pull the individual strand upward until it is completely released from the other strands. To avoid tangling, never pull more than one thread at a time.

The length of your thread is dependent on the size of the stitches. For instance, if you are making long satin stitches, you can cut a length that is 20" to 22". If you are making many small stitches, shorten your length so that it is 16" to 18". Always end a thread when it loses its luster and begins to look frayed.

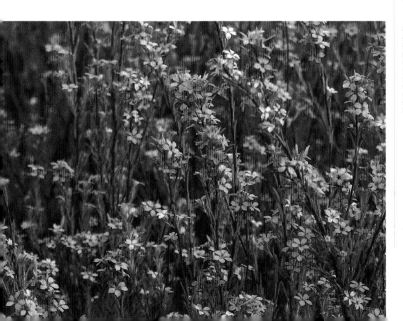

The Flowers

■ Alyssum or Lobelia

THREAD

Flowers: 3 strands—for purple alyssum, use 554, 553, 552, and 550; for white alyssum, use 3865; for lobelia, use 791 or 796

Stems: 2 strands of 319 or 367

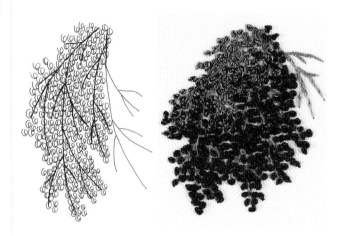

1. Stitch the stems for the alyssum first. This establishes the shape of the plant and gives you a guide for the knots that are applied on top. Stitch the stems in split stitch, with the branches attaching at a pleasing angle and not perpendicular to the main stem.

2. Flowers are done in French knots with 1 or 2 twists. Although the knots are packed tightly together, some of the green stems should be left visible. Try combining 2 colors in the needle for subtle variations and for color transitions. However, do not use more than 2 colors at a time.

> When you begin adding the flowers, first outline the perimeter of each clump with French knots to establish a guide.

▪ Bacopa

THREAD

Flowers: 3 strands of 3865

Stems and leaves: 2 strands of 3346

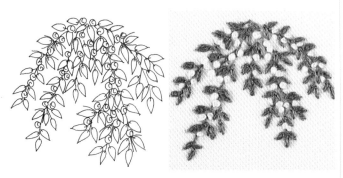

1. Begin by stitching the long curving stems in split stitch.

2. Add the leaves, using small lazy daisy stitches applied opposite one another along the stem. To create larger leaves, add a fly stitch to cup the rounded end of the lazy daisy.

3. Stitch the flowers along the stems, using both single-wrap French knots and colonial knots. French knots are smaller than colonial knots. Colonial knots stand out more.

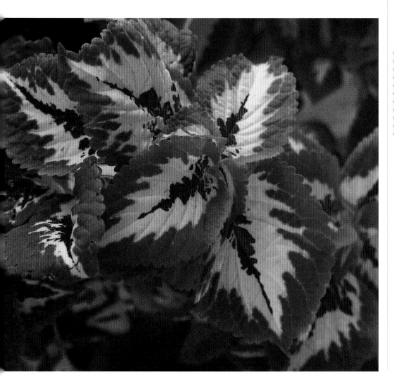

▪ Biden

THREAD

Flowers: 2 strands of 725 or 972 and 2 strands of 3820

Leaves: 2 strands of 895

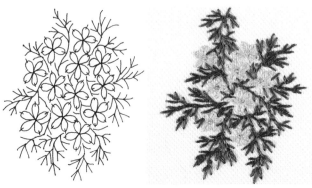

1. Stitch the flowers of the biden using 2 strands of 725 or 972. Each flower is comprised of 5 small lazy daisy stitches beginning in the center of the flower.

2. When all the flowers are complete, insert a French knot in the center of each, using 2 strands of 3820.

3. To begin the feathery foliage of the biden, fill in between each flower with curving stems done in split stitch.

4. For the leaves, start with straight stitches at the tip, followed by 1 or 2 open fly stitches that attach to the stems. Insert straight stitches into bare areas.

> *tip* To create smaller flowers, use 3 strands of floss and make 5 small straight stitches in a star pattern.

■ Browallia

THREAD

Flowers: 2 strands of 340

Leaves: 2 strands of 986

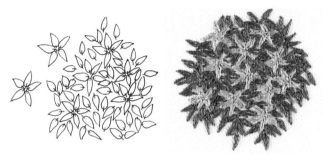

1. Stitch the flowers of the browallia using 5 lazy daisy stitches, beginning each petal at the outer tip to create pointed petals.

2. The leaves consist of many scattered lazy daisy stitches packed into the spaces around the flowers.

■ Chrysanthemum

THREAD

Flowers: 2 strands of various colors

Stems and leaves: 2 strands of 319 or 895

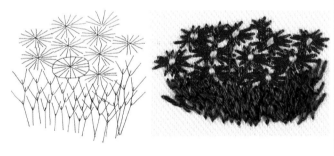

1. Lightly draw a cluster of circles on your fabric as a guide for your flowers. Use star stitch to create each flower.

2. Using 2 strands of a contrasting color, make 2 small parallel seed stitches in the center of each flower.

3. Add some upright, unopened flowers with 4 or 5 small straight stitches, all emanating from a central area.

4. The stems of the chrysanthemum are straight stitches tucked into all the gaps between flowers.

5. The leaves are a mass of overlapping feather and fly stitches at the base of the flowers.

■ Cyclamen

THREAD

Flowers: 1 strand—for pink, use 3608 and 3607 (Cyclamen also come in red and white.)

Stems: 1 strand of 632

Leaves: 2 strands of 520 and 2 strands of 523

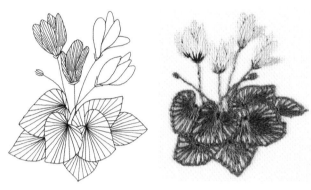

1. Draw the leaves and flowers onto your fabric. Notice that the cyclamen leaf has a slightly pointed tip. Draw guidelines in the flowers to help you maintain good stitch direction.

2. Stitch your flowers in radial satin stitch, using a single strand of 3608. Begin with the foreground petal, followed by the petal that is directly behind it. All petals should butt directly next to each other, leaving no gaps.

3. Using a single strand of 3607 or a darker shade, add some color shading to the petals by applying straight stitches that split through the stitches at the base of the flower. Follow the direction of the radial stitching.

4. Once all the flowers are complete, add the stems. These begin with a fly stitch that creates a cup around the base of the flower; continue in stem stitch. You may want to add buds to the tips of some stems in satin stitch, with a fly stitch cupped around them.

5. The cyclamen leaves are two-tone, so they must be done in a slightly open buttonhole stitch, using 520 as the base color. Once you have stitched an entire leaf, insert 523 into the gaps, using straight stitches that come up just inside the buttonhole edge and slip down to where the threads meet. Complete all the petals in the foreground; then stitch the ones tucked in behind them.

■ Daffodil

THREAD

Flowers: 2 strands of 725 and 2 strands of 3820

Leaves and stems: 2 strands of 3363

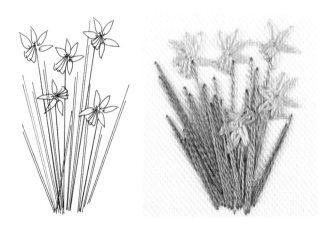

1. To stitch the flower heads, begin by stitching the outer petals, using 2 strands of 725 in lazy daisy stitch. There are 4 or 5 petals; each petal starts at the tip and ends in a central area. Some of your flowers might have all their petals directed upward; others will circle around.

2. Stitch the trumpet of the daffodil using 2 strands of 3820. The trumpet should be directed downward. Begin with a small straight stitch from the center of the flower, followed by 3 to 5 buttonhole stitches, all initiated in the center.

3. The stems are single, long straight stitches. Slip some stems underneath the petals of the lower flower heads.

4. The leaves are each 1 long straight stitch, with a parallel stitch that is slightly shorter.

tip To create slightly larger daffodils, increase the size of your lazy daisy stitches for the flower petals, then insert a straight stitch inside each petal. This will make them fuller.

■ Dahlia

THREAD

Flowers: 2 strands of various colors

Flower center: 2 strands of yellow

Leaves: 2 strands of 3362

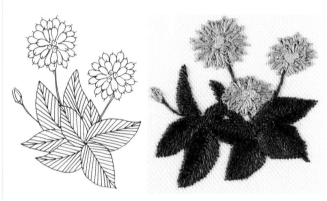

1. Lightly draw all your flowers and leaves. For each flower, draw a small center circle, then a larger outer circle.

2. Stitch the flowers first. Apply a circular row of lazy daisy stitches between the inner circle and the outer circle. Begin these stitches on the inner circle. Divide your circle into quarters, stitching a lazy daisy at each quarter. Fill in each section with 3 or more lazy daisies.

3. Now stitch 8 to 10 lazy daisy stitches, beginning each lazy daisy in the center of the flower and overlapping the first row by half.

4. Stitch 3 French knots in the center, using 2 strands of yellow.

5. Stitch the leaves in closed continuous fly stitch.

◼ Fuchsia

THREAD

Flowers: 2 strands of 718

Stamens: 1 strand of light pink

Leaves: 2 strands of 987

Stems: 1 strand of 987

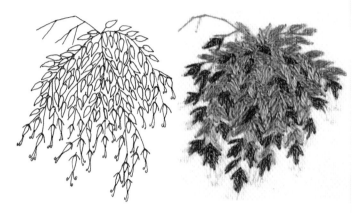

1. Stitch the stems and branches in split stitch.

2. Add the flowers to the tips of the branches. Apply a lazy daisy stitch, with a fly stitch cupped around it. All flowers point downward.

3. To create the stamens, make 2 or 3 pistol stitches, using 1 strand of light pink. The stitches should emanate from the flower tips.

4. The leaves consist of many lazy daisy stitches attached to the stem. Fill in the area solidly. Then add more flowers on top of the leaves and in any small gaps.

◼ Geranium

THREAD

Flowers: 2 strands—for red, use 817 and 349
 (Geraniums also come in pink and coral.)

Leaves: 2 strands of 367 and 320

Stems: 1 strand of 367

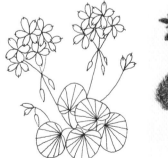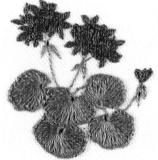

1. Apply a small pencil mark indicating where to position each flower. Draw in your leaves.

2. The flowers are clusters of 3 to 5 individual flowers, each comprised of 2 to 5 small lazy daisy stitches. Begin the lazy daisy stitch in the center of each flower cluster. When you have completed 1 five-petal cluster, create a second cluster either directly next to the first or slightly overlapping it. Continue adding clusters until you acquire the shape and size desired. To bring more liveliness to the geranium flower, combine 2 very close colors. I combined 817 with 349 because they are just subtly different.

3. After completing all of your flowers, attach the stems. The geranium is an umbel type of flower, meaning the flower clusters are attached to multiple stalks that grow from the same point on the stem, much like an umbrella. The stalks can easily be interpreted using 1 strand of 367 and making 3 small straight stitches beginning from the same starting point below the flower. End the stitches so that they are tucked nicely under the flower petals.

4. Stitch the flower stem in stem stitch.

5. Attach 1 or 2 buds done in lazy daisy stitch at the same umbrella point. Be sure to have these stitches dropped downward. Look at the drawing to see where they attach. You may want to insert a bit of red into these buds to suggest that they are opening.

6. Use buttonhole stitch for the geranium leaves. Complete the petals in the foreground, then stitch the ones tucked behind. If you would like the foreground leaves of the geranium to come forward more, combine 1 strand of 367 with 1 strand of 320, or use 320 to fill the gaps.

■ Gerbera Daisy

THREAD

Flowers: 2 strands of various colors

Leaves: 2 strands of 3345

Stems: 2 strands of 3347

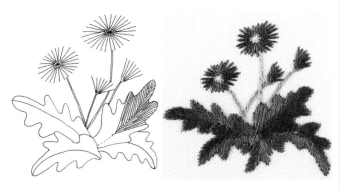

1. Draw a circle for each flower. Then draw the outline and midrib of each leaf.

2. Make the petals of the flowers with straight stitches worked from the outside into the middle, leaving a tiny circle in the center. Maintain good stitch direction by dividing your circle into quarters, then eighths. Fill each section with 2 to 3 stitches.

3. Complete the center of each flower using a single strand of yellow and taking 4 to 5 crossing stitches that pierce into the daisy petals.

4. Stitch the stems in stem stitch.

5. Stitch the leaves in fishbone stitch or the satin stitch leaf variation technique.

■ Helichrysum

THREAD

Stems: 1 strand of 503 or 502

Leaves: 3 strands of 503 or 502

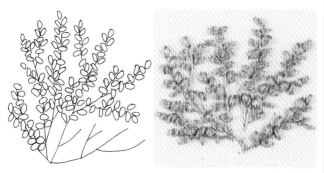

1. Stitch the stems and branches using 1 strand in split stitch. Helichrysum can be upright or trailing.

2. Cluster the leaves around and on top of the stems. Begin with a single-wrap French knot. Then cover that with a small straight stitch directly on top of the knot. If the stitch does not totally cover the knot, apply a second stitch. This stitch combination gives the plant a lovely texture that stands out more than simply applying seed stitches.

■ Impatiens

THREAD

Flowers: 2 strands (Colors vary but are commonly pink, white, purple, or red.)

Leaves: 2 strands of 3345

1. Stitch the flowers with 5 buttonhole stitches worked in a tiny circle, beginning in the center. The buttonhole will slightly close in on itself, but this is a desirable effect. Cluster many flowers together for each plant.

2. The leaves are a mass of lazy daisy stitches filling in all the spaces surrounding the flowers.

■ Ivy

THREAD

Stems: 1 strand of 632

Leaves: 1 strand of 3346

1. The stems, done in split stitch, establish the plant's shape. Attach many branches to the main stem at pleasing angles.

2. Attach leaves to each branch and occasionally to the main stem. Each leaf is comprised of 1 small straight stitch at the tip, with a small fly stitch cupped around it, followed by 1 or 2 flared fly stitches. Attach the tail of the final fly stitch to the end of the branch.

If you want to create a mass of ivy, choose a sequence of green floss, such as 3345, 3346, and 3347, and stitch them in layers. After you've stitched your stems, add a mass of simple leaves that are combinations of straight and fly stitches, using two strands of the darkest color value, 3345. These stitches can overlap one another. Stitch more defined leaves on top of the darker ones using the lighter shades of 3346 and 3347. Try to fill in all the empty spaces. This expedient way of densely filling in a large area will give your ivy depth.

■ Lobelia

See Alyssum (page 7).

■ Marigold

THREAD

Flowers: 2 strands—for orange, use 900; for yellow, use 725

Stems and leaves: 2 strands of 3362

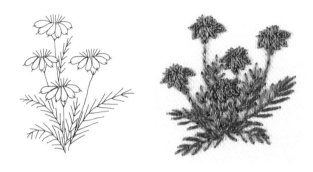

1. Each flower begins with 5 or 6 lazy daisy stitches emanating downward from a central area but not sharing the same initial hole. The stitches should make a semicircular shape.

2. Apply 5 or 6 small straight stitches to the top of each flower, with your needle entering into the lazy daisy stitches. These stitches should fan out a little.

3. Begin your stems by cupping around the flower heads with a small fly stitch, and then split stitch the remaining stem.

4. Use open continuous fly stitches to create the leaves. You can control the curve of your leaf by the direction of the tail that holds down the fly.

◼ Marguerite Daisy

THREAD

Flower: 2 strands—for yellow, use 726; for white, use
 3865

Flower center: 2 strands of 3852

Stems and leaves: 2 strands of 3362 or 935

1. Stitch the stems and leaves using a combination of straight and fly stitches. Begin a stem at the top with a large fly stitch, and then attach several smaller fly stitches and straight stitches. Add more stems and leaves until you have a cluster.

2. Lightly draw small circles on top of the stems where your flowers will be stitched. Use a star stitch to create each flower.

3. Place a French knot in the center of each flower.

4. To stitch buds, dropped flower heads, or a side view of a daisy, straight stitch 5 or 6 petals fanning out upward, downward, or sideways, all emanating from the same hole.

◼ Nasturtium

THREAD

Flowers: 2 strands—for orange, use 946; for yellow,
 use 725

Leaves: 2 strands of 937 and 2 strands of 470

Stems: 1 strand of 470

1. Lightly draw all the flowers and leaves onto your fabric.

2. Stitch the flowers using radial satin stitch, always beginning with the foreground petals. Make sure background petals butt directly next to the foreground ones. The stitches may share a hole with or be tucked just under the stitches of the foreground petal.

3. Insert 3 single-wrap French knots in the center of each flower, using 2 strands of yellow.

4. To complete the leaves, follow the instructions for geranium leaves (page 11). If you observe a nasturtium leaf, you will see that the stem attaches in the center of the leaf. The buttonhole stitch should spiral completely around in a circle. Use 2 strands of 937 for the leaf.

5. To indicate the veins of the leaves, insert straight stitches into the gaps, using 2 strands of 470.

6. Using stem stitch, add stems to connect the leaves with the flowers.

◼ Nemesia

THREAD

Flowers: 2 strands of various colors

Leaves and stems: 2 strands of 3347

1. Lightly draw the bottom petal of each flower onto your fabric. Then stitch these petals in radial satin stitch.

2. Stitch the 4 top petals of each flower in lazy daisy stitch, beginning your stitch at the top of each bottom petal and moving across the width of it. Depending on the quantity of flowers, some of the lazy daisy stitches may overlap the bottom petals of other flowers. This is a desirable effect, as it makes the plant look more realistic.

3. Using 2 strands of bright yellow, apply 2 to 3 small, vertical straight stitches in the flower center.

4. When all the flowers are complete, insert stems, using split stitch, to connect all the flowers.

5. Add leaves using lazy daisy stitches attached to the stem, one opposite another.

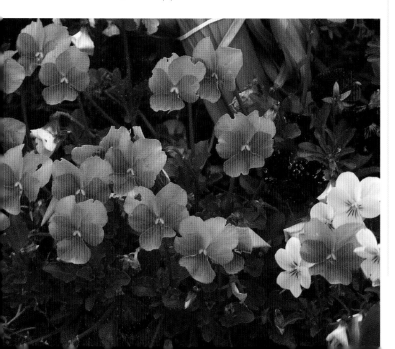

◼ Pansy or Primula

THREAD

Flowers: 2 strands of various colors

Stems: 2 strands of 367 or 319

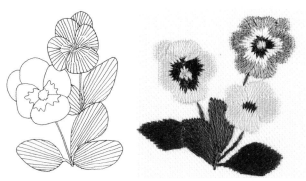

1. Lightly draw the flowers and leaves onto the fabric. Primula flowers are slightly smaller than pansies. Mark where the color change occurs in multicolor flowers.

2. Use radial satin stitch to complete single-color flowers. Create 2- and 3-color flowers using long and short stitch. Whether you are stitching a single-color or a multicolor flower, you must stitch each petal individually. Always stitch the foreground petal first, followed by the 2 petals directly behind it, and then the fourth and fifth petals.

> When you need to switch colors temporarily, simply bring the unneeded color to the surface of your work within the area to be stitched, and set it aside. When you are ready to stitch with that color again, take a pinhead stitch to secure the previous work and continue.

3. Stitch the stems in split stitch.

4. Complete the leaves of the plant in radial satin stitch.

▣ Petunia

THREAD

Flowers: 2 strands—for pink, use 600, 603, 915, and 917 (Petunias come in various other colors.)

Flower center: 1 strand of a darker tone

Leaves: 2 strands of 319

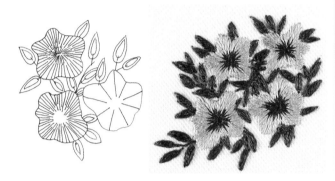

1. Lightly draw the amoeba shape of each petunia onto your fabric.

2. Complete the flowers in long and short stitch. Begin the first row of stitches by coming up from underneath, along the outline of the shape, and bringing your needle back down toward the center, but not directly into the center. Maintain good stitch direction by using guiding stitches to divide your flower into eighths; then fill in each section. You will need to alternate 1 longer with 2 shorter compensating stitches to accommodate the converging in the center.

> *tip* If you find it difficult to achieve a smooth outside edge, split stitch the outline first. Apply your long and short stitches over the split-stitched outline.

3. Using a single strand of a darker tone, pierce into the tips of the first row of stitches from underneath. Drive all of your stitches into the center area, but not all into the same hole. This will give you the trumpet shape of the petunia. Again, you will find it easier to divide this central section into eighths before filling it in.

4. The leaves of the petunia consist of many scattered lazy daisy or double lazy daisy stitches attached to a split-stitched stem.

▣ Primula

See Pansy (page 15).

▣ Salvia

THREAD

Flowers: 2 strands of 817

Flower stalks: 1 strand of 3857

Leaves: 2 strands of 987 or 367

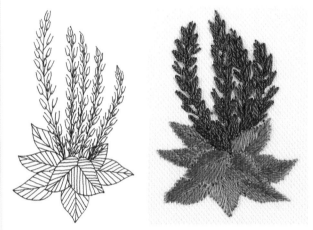

1. Stitch the curved flower stalks in split stitch.

2. Draw your leaves, with midrib, onto the fabric.

3. To stitch the flower, begin at the top of the stalk with a lazy daisy stitch. Add barely open fly stitches or lazy daisy stitches at a pleasing angle all the way down the stalk.

4. Place a few lazy daisy stitches directly over the stalk to achieve a realistic look.

5. Use the satin stitch leaf variation technique for the leaves.

▪ Tuberous Begonia

THREAD

Flowers: 2 strands of various colors (Use DMC floss
 or #8 DMC perle cotton.)

Leaves: Cut from fabric that has been stiffened and
 appliqué to the background.

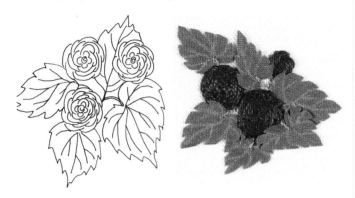

1. The flowers begin with a 2-twist French knot in the center.

2. Circle the French knot with 4 small loop stitches. Continue circling around the flower center with loop stitches until the flower is the desired size.

3. If you find the flower is closing in on itself, gently couch down the final round of looped threads.

> Try both stranded floss and #8 perle
> cotton and compare the results.

4. You will cut the leaves from stiffened 100% cotton fabric. Find a green you like, or paint and heat set a piece of fabric. Brush on diluted fabric stiffener, and hang to dry. The fabric stiffener will prevent your fabric from fraying and will allow you to mold each leaf once it is cut. I use Aleene's Fabric Stiffener and Draping Liquid.

5. Pencil in the basic shape of the leaves, and draw veins using colored pencils. Cut out the leaves; then snip out little triangles to make the sawtooth edge.

6. Appliqué each leaf in place, using 1 or 2 small straight stitches at the base. You may want to tuck leaves under flowers and bend them to add dimension. Use split stitch or stem stitch to interpret the stems.

▪ Tulip

THREAD

Flowers: 2 strands of various colors

Leaves: 2 strands of 320, 2 strands of 367, and
1 strand of 319

Stems: 1 strand of 368

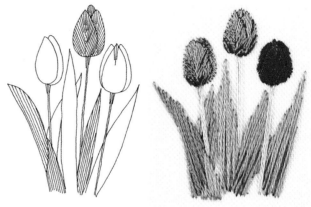

1. Draw your flowers and leaves onto the fabric.

2. Stitch the flowers in the fishbone variation stitch. This creates a nice rib that is characteristic of the tulip petal. Always work the foreground petal first, followed by the petal that is directly behind it. If you have a good photo reference, you will easily see which direction these stitches should take—they butt directly next to the first petal such that no gaps are visible. In some instances, the stitches may share a hole.

3. Stitch the leaves in long parallel or slightly radial satin stitches. Use 320 for the front of the leaf and 367 for the back.

4. To add dimension to the leaves, apply several straight stitches using a single strand of 319. The stitches begin at the base and are parallel to the satin stitch, about $1/3$ to $1/2$ the length of the leaf.

5. The stems are 3 long satin stitches. Angle 2 small straight stitches at the top of the stem to create a more substantial calyx for the flower.

◾ Verbena

THREAD

Flowers: 2 strands—for pink, use 962; for red, use 817

Leaves and stems: 2 strands of 987 or 986

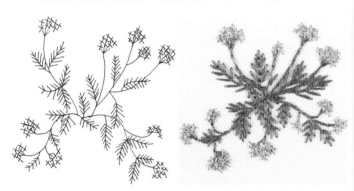

1. Begin with the long curving stems using split stitch. Add many curved branches; these will be for your flowers.

2. The flowers are attached to an umbel stalk, much like the flowers of the geranium (see page 11). Create the stalks for the flowers with 2 or 3 fanned straight stitches at the end of each branch and stem.

3. Stitch the leaves in open continuous fly stitch, concentrating most of them in the center of the plant.

4. Add the flowers by making clusters of tiny cross stitches embroidered closely together in a cone shape.

◾ Wax Begonia

THREAD

Flowers: 2 strands—for red, use 349; for pink, use 3806 (Wax begonias also come in white.)

Leaves: 2 strands of 934 or 935

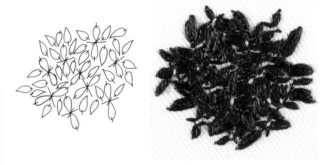

1. Begin each flower with 2 lazy daisy stitches that start in the center of the flower and are opposite each other.

2. Insert a straight stitch across the middle and perpendicular to the lazy daisy stitches.

3. Add a tiny seed stitch diagonally across the center straight stitch, using 2 strands of yellow.

> *tip*
>
> **If you find the flower is not substantial enough, try using 3 strands of floss.**

4. The leaves of the begonia are masses of lazy daisy stitches added to fill in the gaps between the flowers. The leaves should be in equal proportion to the flowers.

Window Box GARDEN

Container gardening is like putting party clothes on a house. What sort of impression does the owner want to make? Gregarious speaks with lots of color. Charming says I have a nice personality and I am pretty. Sophisticated promises a more cultivated image, while quiet might look for subtlety and poise. Dressing up your home with flowers is an extension of who you are. Of course, it helps if you happen to like gardening!

Making container gardens in paint and embroidery allows you to express your personality without actually having to garden. You can make your garden as idealistic as you want. Because I am a gardener, I try to follow the rules of keeping shade plants separate from sun plants, and I consciously match plants to the correct seasons. But I have had many a defiant student who insisted on mixing things up, such as putting spring bulbs into a summer basket. Why not? Sometimes we can get too caught up with reality, and we need to let go and dream a little.

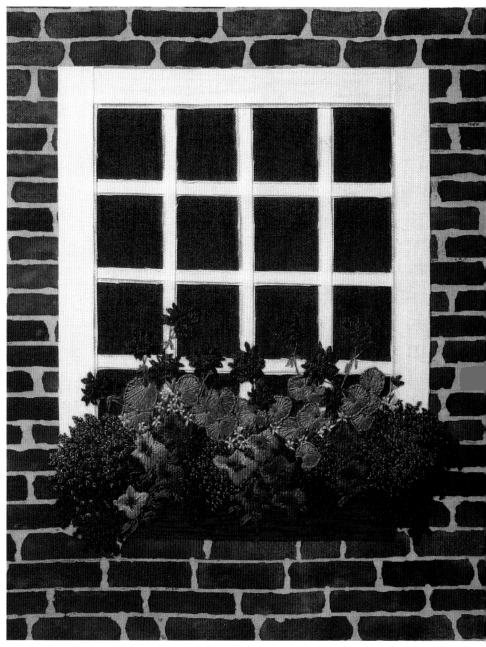

Window box garden with geraniums and alyssum

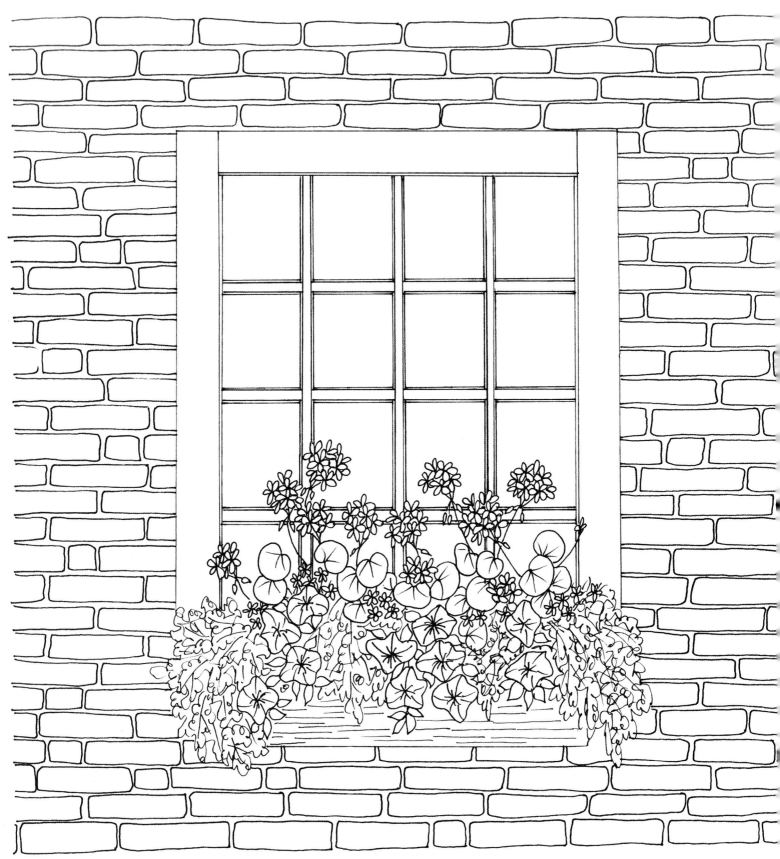

Design for window box garden

Design is full size.

This project guides you through the creation of a simple window frame and garden box set against a painted wall. You will learn how to use silk paints with gutta resist to create different wall finishes: brick, stone, stucco, or wood siding. After painting, you will cut fabric and fuse it to your painting to build the window frame. The fun begins when you design a window garden to express your personality. I have included several window garden designs to get you off to a good start.

For ease of explanation, I will guide you through a specific window frame design that measures $4^3/_4$" x $5^1/_4$" and has three windowpane dividers, both horizontally and vertically. If you follow directions easily, you can change the dimensions and style to suit your taste.

Supplies Needed

2 pair $^3/_4$"–square softwood stretcher bars:
 1 pair 13" long and 1 pair 17" long
Photocopy or tracing of window design
Flat brass tacks (preferably Japan tacks)
Tack remover or flathead screwdriver
1 yard prewashed white 100% cotton quilting fabric
1"–2"-thick book (soft or hard-cover, at least 9" x 10") to fit under your frame, used as a hard surface to transfer designs
Water-based silk paints (such as Pebeo Setasilk) in ebony and various colors, depending on your wall choice
Size 10 (approximately) artist's watercolor paintbrush
$^1/_2$-oz. plastic gutta applicator bottle with #7 metal nib
Clear water-based gutta (such as Pebeo or Dupont)
Iron
Table salt in a salt shaker
Plain paper, the size of your window frame
Paint palette
Medicine syringe
Container for water
Small cotton lint-free rags
Hair dryer

Rotary cutter and mat
12" cork-backed steel ruler
4" x 12" paper-backed fusible web (such as Wonder-Under made by Pellon)
4" x 12" colored or white 100% cotton quilting fabric for the window frame
DMC embroidery floss in colors 817, 349, 367, 320, 554, 553, 552, 550, 600, 603, 915, 917, 319, 972, 3820, and 895 (if completing the design on page 20)
Crewel embroidery needles, sizes 7–9
Gray artist's-quality colored pencil (and other colors depending on your wall choice)
Sharp pencil
Water-soluble fabric marker (optional)
Quick-grip clamp with 6" opening or c-clamp to attach your frame to a table for the embroidery
Tape

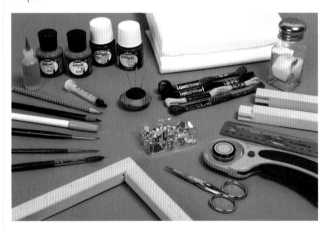

A selection of supplies

Getting Ready

I have found that 100% cotton quilting fabric works wonderfully for creating the window box scenes. Its mat finish and slightly heavier weight are perfect for the painted walls. Before you begin, always wash your fabric to remove any finish that the manufacturer may have used that might repel the paints. For the design on page 20, cut your yard of fabric into 2 pieces, each 16" wide x 17" long. One piece is for the design, and the other will be used later to back your embroidery.

If you are in a hurry or are not ready to try your hand at a painted background, try using some of the preprinted texture fabrics currently available in brick, wood grain, or stone. Create the window following the instructions in the projects. Then add your embroidered flowers. For an example of this, see the window garden scene on page 36, and read the accompanying caption that offers tips. You can also try printing photos of your own window on fabric and adding embroidery. See *Photo Fun* in the Bibliography (page 62) for more information.

Preprinted fabrics that you can use in place of painted fabrics

Read Stretching Your Fabric for Painting (page 58) and Working With Gutta Resist and Silk Paints (page 59) before you begin. These instructions are important and will ensure that you get off to a good start. Once your fabric is stretched onto the frame, you can create the windowpane.

Creating the Windowpane

A dark, neutral windowpane color provides the perfect background for your embroidered flowers.

APPLY THE GUTTA

1. Place your photocopy of the design on top of the 1"–2"-thick book. The book provides a firm surface for the gutta application and brings the design directly underneath your cloth, ensuring good visibility. Make sure your design is centered and straight under your stretched fabric.

2. Using your cork-backed steel ruler, apply a line of gutta all the way around the inside edge of the window frame (enclosing the windowpane). Your gutta nib should touch the fabric and be at a 45° angle. Your pane should measure approximately $3^3/4''$ wide by $4^1/2''$ high. Be careful not to smudge the wet gutta, and always wipe away any excess that adheres to the underside of the ruler after each application.

3. Reinforce your outline by applying an abutting row of gutta to achieve a solid barrier that prevents the color of the windowpane from seeping into the wall color, or vice versa. Don't panic if the line is a little sloppy; it will be covered by the appliquéd window frame.

4. The thickness of quilting cotton often does not allow for complete penetration of the gutta. To ensure that your barrier is solid, turn over your frame, being careful not to smudge your wet gutta on the front. Apply gutta freehand on the underside, following the same outline that is on the front.

5. Allow the gutta to dry completely; it will take about 1 hour to air dry. You can speed the drying time with a hair dryer.

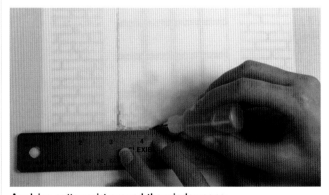

Applying gutta resist around the windowpane

Never leave your design under the gutta as it is drying. The black ink will transfer from your photocopy onto your fabric and cannot be removed.

PAINT THE WINDOWPANE

1. To create the gray or black of the windowpane, use ebony silk paint. If you prefer a lighter-colored pane, dilute the ebony with water to the desired shade. Test your color on the edge of your fabric first. Dry it to get a true sample; the paint color is darker when wet. You need only a small amount of paint to fill your space.

2. Wet the window with your paintbrush and water, absorbing the excess moisture with your rag. Fill in the area with the ebony paint. Be careful not to over-saturate the area; this could cause bleeding over the barrier or puddling. Paint does not move as freely on cotton as it does on silk (which you will use in another project), so work in your paints until you have a nice, smooth application. Don't worry too much about slight imperfections.

3. Allow your painted pane to dry naturally for smoother results. Leave your work in a horizontal position to prevent the color from leaking over the gutta barrier.

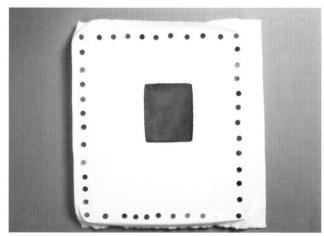

The painted windowpane

You are now ready to choose a wall type. Once again, you will be using silk paints with gutta resist. Colored pencil is also incorporated in the wood siding and stone walls.

Wall Types

Instructions are provided for four different wall types: wood, brick, stone, and stucco. You can choose to do any one of these or a combination for your project. Be careful not to make your wall too busy, as this can detract from the focal point of the design, which is the window garden. All the wall types are simple to complete, although the brick and stone take more time to execute.

WOOD SIDING

Wood siding

This is the easiest wall to paint because it requires only one even wash of color.

1. Even before the windowpane is dry, you can carefully wet the fabric outside the gutta barrier. Absorb any excess moisture with your rag.

2. Mix a sufficient quantity of color to cover the wall. Test and dry your color on the edge of your fabric first.

3. Apply the paint to your wall with your watercolor brush until you have achieved an even color. Allow it to air dry.

4. If you find the color is not completely satisfactory, apply a second modified color while the fabric is still damp. If your fabric has dried completely, turn over your frame. Using an iron, heat set the paint for 1 minute on the underside of the painted fabric. Then rewet the fabric and apply the new color. Because these are translucent paints, you can only go darker than the existing color. Keep in mind that the base color will affect the new color. For example, red painted on top of yellow will produce an orange tone, unless the yellow is exceptionally pale.

5. When your painting is complete and thoroughly dry, remove the fabric from the frame, and heat set it for 3 minutes.

6. Wash the gutta out of your fabric (see page 60, step 8).

When heat setting your paints, be sure they are dry, and use a scrap of cotton on the bottom and top of your fabric to ensure that no dye is transferred to the iron.

Drawing in the Boards

1. Before drawing in the boards, stretch your fabric with a backing fabric for embroidery (see page 60).

2. After your fabric and backing are stretched tightly onto the frame, apply the lines that create the boards of your wall. Use good-quality artist's colored pencils, such as Prismacolor, because they have more pigment than the less-expensive student type. You can purchase these pencils individually at art supply shops. Select a shade of gray that is a much darker value than your wall color.

3. Place your book under your frame to create a hard surface for the colored pencil work. Draw a horizontal line across the top of your window. Make sure it is not an angled line.

4. On each vertical side of your wall, use a ruler to mark out the spacing of the boards from the line you drew in Step 3. Use a photograph as a reference to discern the distance between boards. Join the marks. An alternative method is to use a clear quilter's ruler that has grid lines marking inches and centimeters. Make sure your pencil is sharp to achieve a fine line. Because the lead in artist's-quality colored pencils is soft, you will need to sharpen it several times.

5. When the lines are complete, draw in the occasional vertical line to indicate siding board ends. I like to shade very lightly under each board with the same pencil. You are now ready to move on to the window frame (page 28).

If you want to create textured barn board, apply a darker shade of your mixed paint color to the wall after it has dried. Brush it on roughly in horizontal strokes and then add some of the original color to completely saturate your wall. This will give you a streaky effect. Later you can add some wood grain with colored pencil.

Barn board

BRICK

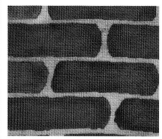

Brick wall

Although brick is time-consuming to complete, the results on fabric are fantastic and not difficult to accomplish. First, you create a background color that will represent your mortar, keeping in mind that it will also affect the brick color. Salt is used to create the speckled effect so prevalent in older brick houses.

Mortar

1. Begin by mixing a color on your paint palette with small amounts of diluted silk paints. Decide if you want a gray tone or a warmer sandy tone. I like to use cinnamon, silver gray, and old gold, with moss green added last to tone down the color. When mixing your colors, keep in mind that they will be lighter in color when dry.

2. Prepare your fabric by wetting around the window with water, using your paintbrush and being careful to avoid the windowpane. Absorb the excess moisture with a rag before evenly applying your diluted color onto the fabric. Sometimes you will need a second application if the initial color is too light.

3. Cut a rectangle of paper the same size as your windowpane, and lay it on top to protect your pane color from the salt. Sprinkle salt liberally over the fabric.

4. Remove your protective paper and any salt that may have landed on your pane. The remaining salt on the wall will draw up the paint, creating a wonderful speckled effect. The longer you leave the salt, the more dramatic the results will be. Make sure your fabric is stretched taut to avoid a starburst effect. Observe your work throughout; the whole process takes only 15 to 30 minutes.

5. When you are satisfied with the results, brush the salt off as you dry your work with a hair dryer. This will stop the salt action. Make sure no salt is on your windowpane. Salt has an incredible pulling effect on the paints; it takes very little moisture for a reaction.

6. Turn over your frame, and heat set your paint on the underside of the fabric for 1 minute.

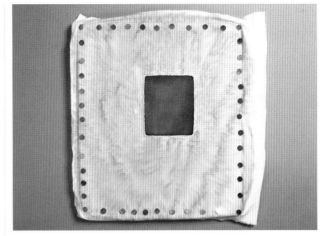

Notice the wonderful speckled effect that results from applying salt.

With the mortar color complete, now you will draw around each brick with the clear gutta. This will preserve your mortar color so you can paint in the bricks.

7. Cover your book with a white sheet of paper, and place it underneath your fabric to provide a hard surface. You will apply all the horizontal gutta lines first. From the many students I have taught, I have learned that the application of gutta is different for everyone. Some people produce thick lines; others, thin ones. I suggest you apply the gutta lines by eyeballing the width, rather than measuring $3/8''$ intervals only to find that your bricks are either too wide or too narrow as a result of your gutta line thickness.

8. Place your ruler across the top horizontal line of your windowpane. Stand over your work to ensure that the ruler is perfectly horizontal. Apply your first gutta line. Continue adding lines, progressing to the bottom and avoiding the windowpane, always using your ruler to achieve straight parallel lines. It is easier to work this step if you are standing. When finished, rotate your frame and complete the top half. Be sure to wipe the back of your ruler after each line. Correct any broken lines.

9. Once the horizontal lines are complete, carefully apply the vertical lines to represent individual bricks approximately 1″ long. Do 1 row at a time. You need your ruler only for the first row. Place it underneath your last line of gutta, and mark off a row of 1″-long bricks. Each subsequent row should have vertical lines

halfway between the vertical lines of the previous row. Double wall brick houses have some of the bricks placed with their ends exposed. This type of wall does not have a regular repeat pattern, and I find it makes the wall more interesting to look at. My design on page 20 is drawn this way.

10. When the gutta is complete, remove the paper and book, and allow the gutta to dry thoroughly.

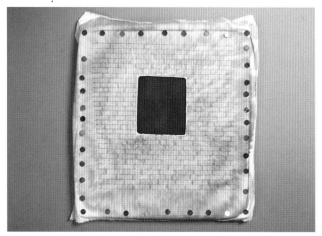

Each brick is outlined with gutta resist to represent the mortar.

Painting the Bricks

Now you are ready to mix your paints for the bricks. To achieve a warm red brick color, I like to start with a base that combines cinnamon, hermes red, and moss green diluted with water. Then I remove some of my base color with a medicine syringe and mix 2 darker tones, adding more moss green to 1 and ebony to another.

> You do not need to wet your fabric prior to this paint application because you are not trying to achieve a smooth application of color like you did in the windowpane.

1. Apply your base color to all of the bricks, and allow it to partially dry; you may use your hair dryer for this. Now randomly apply small amounts of the darker tones on individual bricks. You can strive for a very regular pattern or a more spontaneous effect.

Notice how the salt texture comes through in the bricks in a very subtle way and continues to separate the colors.

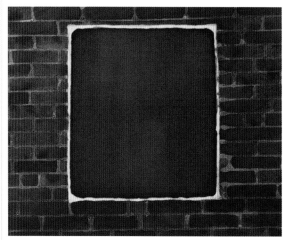

Apply a base color overall, then add darker values to individual bricks.

> If you want a salt-and-pepper look to your brick, mix all your colors in advance, and paint each brick individually.

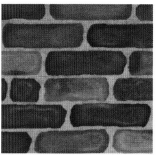

Salt-and-pepper brick

2. If you find that the color is not of the desired intensity, apply a second base coat, keeping in mind that you may also need to mix and add darker values. You can apply more salt if you have lost your speckled effect, but monitor it carefully and dry with a hair dryer when the desired results are achieved.

3. Once your fabric is thoroughly dry, remove it from the frame, and heat set it for 3 minutes.

4. Wash the gutta out of the fabric (see page 60, step 8), and stretch your fabric in preparation for the embroidery (page 60). Then apply the window frame (page 28).

STONE

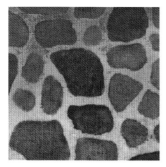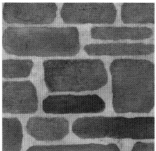

Examples of stone walls

Dilute clear gutta by up to 25% with silk paint or black gutta to slightly darken or color the gutta line used for the mortar. If you want a slightly darker mortar, add ebony silk paint to your clear gutta. If you would like a very dark mortar, add black gutta to it. Although you can purchase gutta that is already colored, it does not remove completely during the washing process, making it too difficult to stitch through.

Windows on stone buildings are always deeply recessed. Since you will be appliquéing the window frames on top of your painted walls, you need to create the illusion of a recessed window. To achieve this, with your pencil and ruler, draw a frame around the windowpane that is 1/2" deep. Create your stone wall around this second frame to allow for the placement of the appliquéd window frame without cutting off the stones, which would look unrealistic. Shading the stones with colored pencils following the painting process also adds depth and dimension.

Because stone walls are painted in much the same way as brick, read the instructions for brick (pages 24–26) before proceeding. Determine what type of stone wall you want to create. Some students use fieldstone with rounded shapes. Others use precisely cut rectangles and squares. The color of stone varies enormously as well. I encourage you to look at lots of resources to discern what you would like. All stone walls are very simple to complete.

1. Just as for brick walls, begin with a base color that represents the mortar and that has an effect on the stone color. If you want a mortar darker than your base color, you will need to add silk paint or black gutta to the clear gutta that outlines your stones.

2. Decide if you want a base color with a strong or mild speckle effect in your stone. As with the brick walls, use the salt technique to achieve this look (see page 25, steps 3–6).

3. Once you have applied, salted, and heat set your mortar color, draw the stones freehand with the gutta applicator. If you have a good rendering of your wall as a guide, drawing the stones will be a cinch.

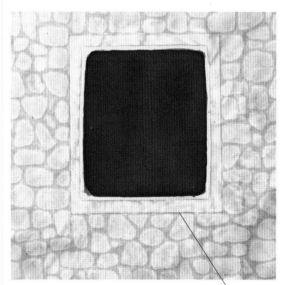

Gutta outlines the stones. *The pencil-drawn window frame*

4. When your gutta is thoroughly dry, mix your stone colors. Apply a base color overall or use it selectively in individual stones. Make a few subtle variations of this color, and apply them individually into stones. You can also mix colors together within stones. As your painting dries, you can add new colors, which will spread less and be more concentrated.

5. When you are satisfied with the results, completely dry your painted fabric with a hair dryer. Remove the fabric from the frame, and heat set it for 3 minutes.

6. Wash the gutta out of the fabric (see page 60, step 8), and stretch your fabric in preparation for the embroidery (page 60).

7. Once your painting is stretched taut, take a good look at your results and decide if the stone wall looks too flat and could use more dimension. If so, use a dark gray colored pencil to shade the edge of the stones, particularly the ones surrounding the window frame. When this is done, apply the window frame (page 28).

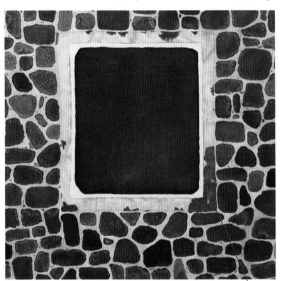

This stone wall is now ready for the window frame.

Any paint leakage will be covered by the frame.

STUCCO

Stucco examples

Creating a stucco wall is the most expedient choice, and the effects can be splendid. Read the instructions for the mortar part of the brick wall (pages 24–26) for more detailed information.

1. Use your paintbrush to wet the fabric before applying your tested color. Apply the paint.

2. Protect your windowpane with a piece of paper while you sprinkle on lots of salt. A second or third application of color and salt may be necessary to acheive the desired results.

3. When you are satisfied, brush off all the salt, remove your fabric from the frame, and heat set it for 3 minutes.

4. Wash the gutta out of the fabric (see page 60, step 8), stretch your fabric in preparation for the embroidery (page 60), and you're ready to apply the window frame.

Applying the Window Frame

Now that your wall is painted and your fabric is stretched with a backing, you will add the window frame, which you will cut from a solid-color cotton backed with fusible web. Purchase the type with a paper backing. I prefer Pellon's Wonder-Under Transfer web.

CHOOSE A FRAME COLOR

If you chose a color for your frame before painting the wall, is the color still suitable? Do you want a high-contrast, a monochromatic, or an analogous color scheme? Think about the architectural style, mood, and floral theme you are creating. If you cannot find the right color, consider mixing your own color using silk paints to paint a piece of fabric for your window frame.

BUILD THE WINDOW FRAME

The window frame consists of two layers of carefully cut cotton with a fusible-web backing: a base layer, which is applied first, and a slightly narrower frame, which is ironed on top. This layering creates dimension and eliminates the transparency of the first layer.

1. Apply the fusible web to the wrong side of your 4" x 12" strip of window frame fabric. Follow the manufacturer's instructions.

2. With your rotary cutter, trim away any fabric that does not have fusible web on it. Peel off the paper backing.

3. To cut the frames, use your rotary cutter, a cork-backed steel ruler, and a rotary mat. The frames must be precisely cut and applied.

Important: Keep your piece stretched on the frame at all times while applying the window frames.

4. Top your book with layers of cotton or tissue paper for padding. Place the padded book under your project as you fuse the window frame pieces. The following instructions for applying the different layers refer to the illustration on page 20. It is best to begin with a simple frame like this and progress to more challenging ones or designs of your own.

> When fusing pieces onto your fabric, place your iron down flat in a single motion. This will prevent any shifting of your windowpane dividers.

Apply the Base Layer of Dividers

Cut and apply the base layer of the windowpane dividers first. Make sure your work is right side up, with approximately 4" of wall beneath your window frame to accommodate your garden.

1. Measure your painted windowpane width and height.

2. Use your rotary cutter and ruler to cut a rectangle that is approximately $1^1/2$" wide by the height of your pane. From this, cut 6 strips that measure $3/16$" wide by this length. Do not measure all the widths at once. Measure $3/16$" first; mark with a pencil dot; then cut and repeat.

3. Set 3 of these pieces aside; they are your vertical dividers. Cut 2 of the remaining $3/16$" strips the width of the windowpane; these are your upper horizontal dividers. Remember to keep them all right side up as you work.

4. Arrange the 3 vertical and 2 upper horizontal window frame dividers within the painted window-pane, using a large sewing needle to help you carefully place them.

5. Now you will create the bottom horizontal divider. Measure the exact distance between the vertical dividers. Cut the remaining $3/16$" strip into 4 pieces that will butt next to the vertical dividers. Use your needle to carefully place these pieces. Cutting the horizontal divider into 4 pieces like this reduces the layers of fabric and adhesive that your embroidery needle must go through to create your flowers.

6. With your book beneath the frame, recheck that you are content with the placement of the dividers. Very gently place a square of tissue paper on top of the fabric, and heat set the base layer.

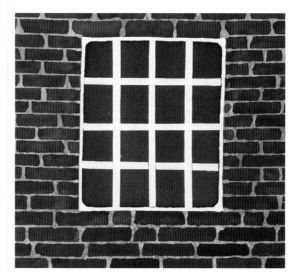

Apply the base layer of dividers first.

> Working with narrow strips of light-colored fabric can be tricky. It is easy to accidentally place a piece wrong side up and find it attached to your tissue paper instead of the windowpane. But what do you do if the piece fused to your paper was underneath another window frame divider? Don't worry! While the fabric is still warm from the iron (or after you have rewarmed the fabric), gently remove all the frame members connected to it. Use your large sewing needle to lift the fabric strips. Try not to fray any pieces that remain.

Apply the Second Layer of Dividers

The second layer of windowpane dividers is slightly narrower than the first and centered on top. These pieces are also slightly longer than the first layer.

1. Cut strips that measure $1/8$" wide by the length of each of the frame dividers plus $1/8$".
2. Place the horizontal dividers first, centering them exactly within the base layer. You can trim their length as you place them.
3. Press the dividers in place, remembering to put your tissue paper on top. Then place the vertical dividers on top, again centering them exactly. Iron in place. If you are confident, you can place them all at once.

Apply the Base Layer of the Outside Frame

1. Cut 2 vertical frame pieces that measure $1/2$" wide by the height of the pane plus 1". Place these pieces on your frame, overlapping the horizontal bars slightly and butting next to the windowpane.
2. Measure the horizontal distance between the inside edges of the 2 new vertical frame pieces. Cut 2 pieces $1/2$" wide by this distance. Butt these pieces against the vertical frame, overlapping the vertical windowpane dividers slightly. No gutta lines should be visible, only the black of the pane. If you can see white, make your frame smaller.

> You can use a permanent black fabric marker to touch up white corners.

3. When all looks good, lay your tissue paper on top, and iron in place. Don't worry if you notice that the individual windowpanes vary slightly in size. Your audience will be focused on the embroidery and overall effect; they will not be measuring each windowpane.

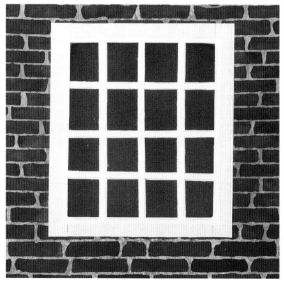

The outside frame overlaps the window dividers and completely encloses the painted windowpane.

Apply the Second Layer of the Outside Frame

In this final step, you will be applying only the head and sides of the frame, since the sill of the frame will be entirely stitched over. Before beginning, make sure your work is right side up.

1. Measure the height of your window frame. Cut 2 pieces $7/16$" wide by the height. Place the pieces, aligning them with the outside edges of the frame. The pieces should be narrower than the base layer.
2. For the head of the frame, measure the horizontal distance between the inside edges of the newly placed vertical pieces. Cut 1 piece $7/16$" wide by the measured length plus $1/8$" to allow for the vertical pieces to overlap. Again, this piece should be narrower than the base layer. Put it in place, aligning it with the outside edge of the upper horizontal frame. The ends should tuck under the 2 new vertical frame pieces.
3. Iron in place.

Add Shading

To add dimension to your frame, use an artist's-quality gray colored pencil to shade the base layer of the window framing, especially on the lower edges. Add colored-pencil shading directly to your outside frame to give it more texture if you like. Your window frame is

now complete. Take a break and think about what material you might like for your window box.

Creating the Window Box

Like the window frame, your window box will be cut from fabric and applied with fusible web. There are a myriad of window box styles. You need to determine how important a feature your box is. If 80% of the box will be covered by hanging flowers, then it is best to keep your design simple. Your color choice is the most important feature, and perhaps you can add some texture to it. If your box is wood, you can either use a brown fabric or paint a small swatch of fabric using silk paints. You can create a wood grain effect by adding some simple straight stitches for texture. If you want to have a predominantly upright garden, however, the design of your box will need more consideration. You could iron on small squares of color to create a pattern, stitch a border along the edges, or paint and pencil in a design.

Determine the depth and width of your box and whether it will be square, slanted, or curved at the ends. If in doubt, trace the pattern shown below. Position your window box directly below your window frame and adhere it with fusible web.

Some manufacturers of fusible web require the application of a damp press cloth to permanently bond fabrics. Read the accompanying instructions for the fusible web you chose. With your frame complete and the window box added, now is the time to permanently bond these fabrics.

Embroidering the Garden

Follow the directions in the Flower Gallery (pages 6–18) and the Stitch Directory (pages 47–57) to create the flowers for your window box.

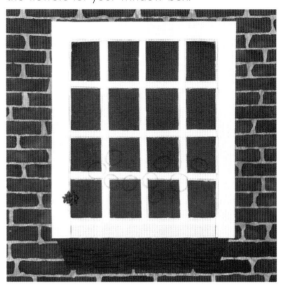

Notice how the blue circles correspond with the illustration on page 20 to mark where the geranium flowers are placed. Straight stitches have also been added to the wooden window box in areas that will be exposed.

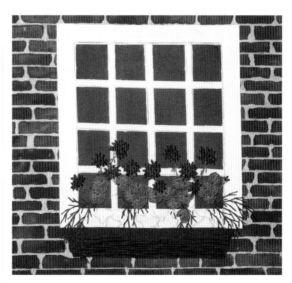

The geranium flowers are stitched first, followed by their leaves. Notice how one leaf is tucked under another. The stems of the alyssum are applied next to establish the shape of the plant.

Outline for a window box　　　　　　　*Pattern is full size.*

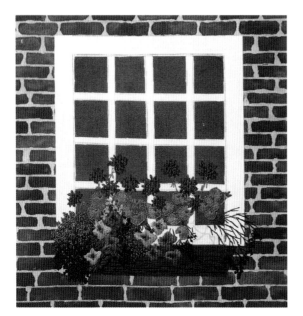

After the knots for the alyssum are filled in, the petunia flowers are stitched. Green foliage fills in all the remaining spaces. A sprinkling of bidens is added to liven up the garden.

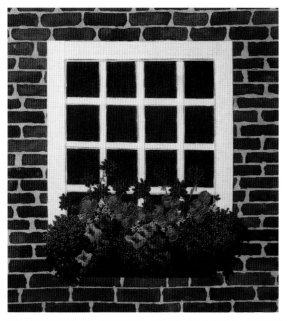

More petunias are stitched in, along with alyssum and bidens. There are absolutely no gaps left in the core of this garden.

Designing Your Own Garden

You can choose from a myriad of plants for your window boxes. First, think about the season you would like to portray. If it is a spring box, include tulips, daffodils, primulas, or pansies. A fall box might contain chrysanthemums, asters, and ivy. Summer boxes can contain a huge variety of flowers. Annuals are most commonly used, because they remain in constant bloom. Most of the instructions in this book are for annuals. Try to keep shade plants separate from sun-loving plants. Of course, you can choose to defy all the rules and put whatever you please in your box.

Before you begin to stitch, design your garden on paper. You do not need expert drawing skills to accomplish this. I draw my flowers much like the shape of the stitches used. For example, geraniums are composed of clusters of overlapping lazy daisy stitch flowers with a fly stitch stem. You can use tracing paper to trace flowers in books; this also helps you understand the contours of flowers.

When you have determined which flowers you would like to include in your box, trace the outline of your box and window frame on paper and make a few copies to try out different garden designs. Try drawing some pleasing compositions of your flower choices. This exercise not only helps you determine which plants to choose and where they will go, it also ensures that you draw your flowers in proportion to each other and the window frame.

If you do not have an actual source to draw from, use reference books as resources to plan your design. There are many excellent books on window gardening. Books that offer simple outline drawings indicating placement of plants are an invaluable resource (see Bibliography, page 62, for a list). Although the drawings are just squiggly blobs, they help you to quickly determine the placement of plants and not get overwhelmed by variety, color, and hundreds of leaves.

In the Flower Gallery (pages 6–18), you will find instructions to complete a full plant or a cluster of a specific flower and foliage. When designing a window garden, only parts of each plant will be visible, as one flower is placed in front of another. Attempt to illustrate an overlap of leaves and flowers in your embroidery to achieve a more realistic look. Keep the design spontaneous, merge one plant with another, and avoid round independent clumps. Your embroidered garden should be packed tight with flowers and foliage. You don't want a skimpy-looking embroidery any more than you would want a skimpy garden. Make it lush!

Once your drawing is complete, you can proceed to the embroidery. Refer to Transferring Details (page 6) for important tips on using a water-soluble fabric marker or a sharp pencil to lightly mark the placement of each flower on your project.

> If the thought of drawing directly on your project intimidates you, trace your design onto artist's tracing paper, and use a colored fabric tracing paper to transfer the necessary design elements.

There are no definitive rules for which flowers should be stitched first, but I usually like to begin with individual large flowers, such as geraniums and pansies. Often, my window boxes will evolve and new things will be added, but my drawing remains my most valuable reference. Because I live in a climate that has long, cold winters, I must either match my floss colors in the summer while things are in bloom or use the photo resources in gardening books. Remember that outdoor light varies and has an enormous effect on the color a plant appears to be. The green of a leaf can look quite different on a gray day than on a sunny day. You will also want to contrast the green of one plant against the green of another to help distinguish between them.

When choosing colors for the flowers in your window garden project, remember to consider value and tone. Value is the relative lightness or darkness of a color. Darker colors have a low value; lighter colors have a high value. When you place strongly contrasting values, such as light yellow and dark purple, next to each other, you stimulate greater visual excitement than when you place two similar tones together. If you choose floral colors that are the same value as your wall, your results will be flat and uninteresting. To achieve dimension, your picture requires a range of light and dark colors.

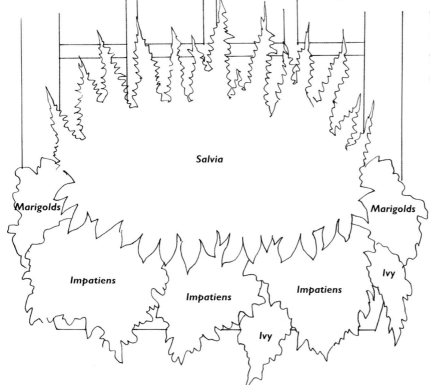

Salvia

Marigolds

Marigolds

Impatiens

Impatiens

Impatiens

Ivy

Ivy

Tracing outlines of plant groupings from a photograph helps you see the placement. Use a photocopier to enlarge or reduce images to the correct size.

More Window Box Garden Designs

Instead of designing your own garden, you might want to use one of the following designs. Each of these could be used with the window frame and wall you just created.

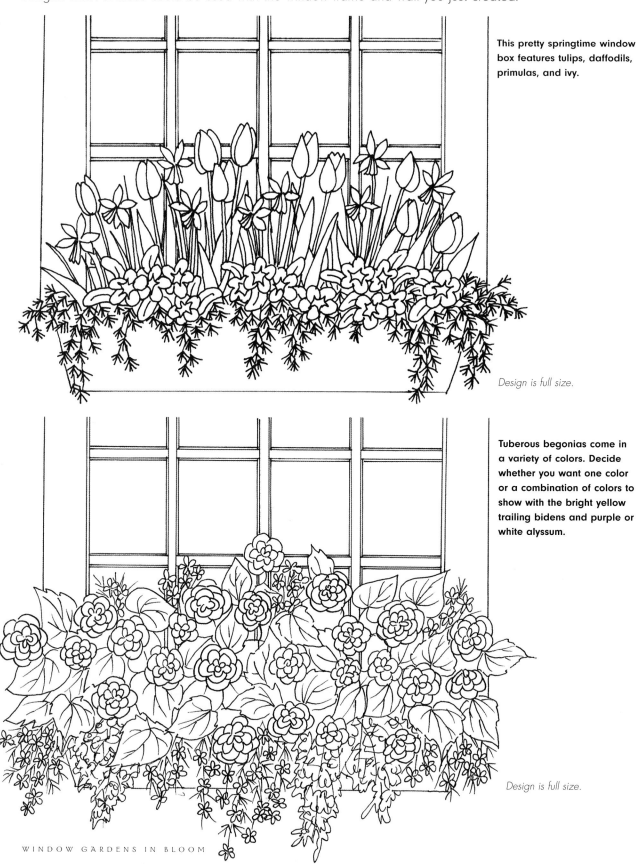

This pretty springtime window box features tulips, daffodils, primulas, and ivy.

Design is full size.

Tuberous begonias come in a variety of colors. Decide whether you want one color or a combination of colors to show with the bright yellow trailing bidens and purple or white alyssum.

Design is full size.

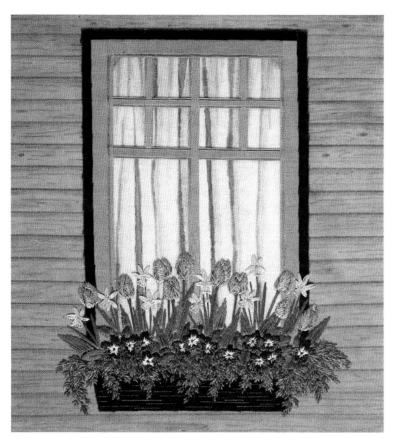

The soft colors of this spring window garden against the weathered clapboard have a quiet presence. The curtains were created using gutta resist and silk paints, followed by colored pencils to shade each pleat.

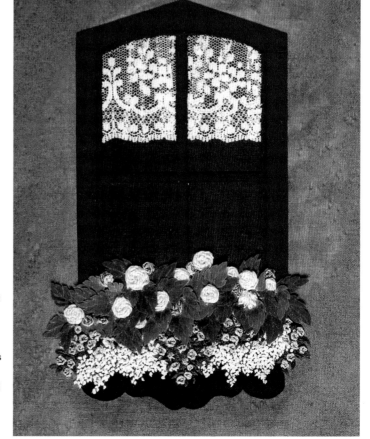

I like to use rich heritage colors for my stucco walls. The lace curtain is reminiscent of European windows. I cut lace trim into strips and applied it with fusible web, then carefully stitched it in place. When using stiffened fabric, as for these tuberous begonia leaves, it is important to select embroidered flowers that are very textural to complement the three-dimensional effect of the leaves. Alyssum and impatiens are good choices.

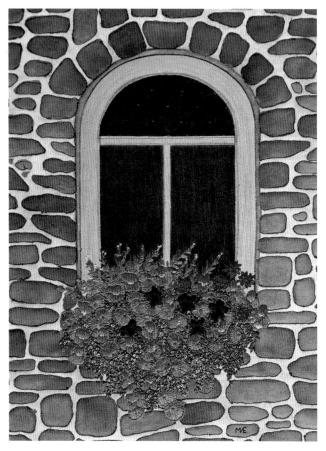

This cheery summer window garden displays a secondary color scheme, providing lots of liveliness. To make the garden stand out, I used a darker value for the windowpane. Free-motion machine embroidery was applied around each stone and the window frame to add more depth to the wall.

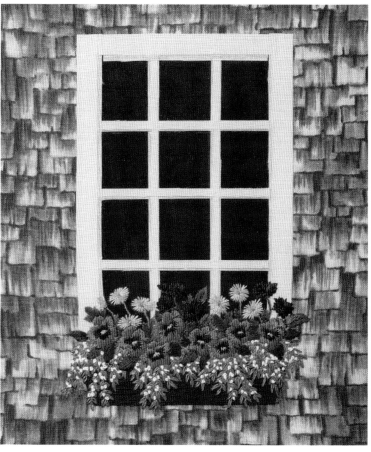

For this window garden scene, I used preprinted fabric for the shingle walls, and I painted the windowpane using Pebeo opaque black textile paint prior to applying the window frame. When using preprinted fabrics, adjust the size of your window and garden to the scale of the print.

For example, commercially printed brick fabric is often smaller in scale than the size of the bricks in my projects; therefore, the window and garden need to be proportionately smaller.

project 2

Windowsill GARDEN

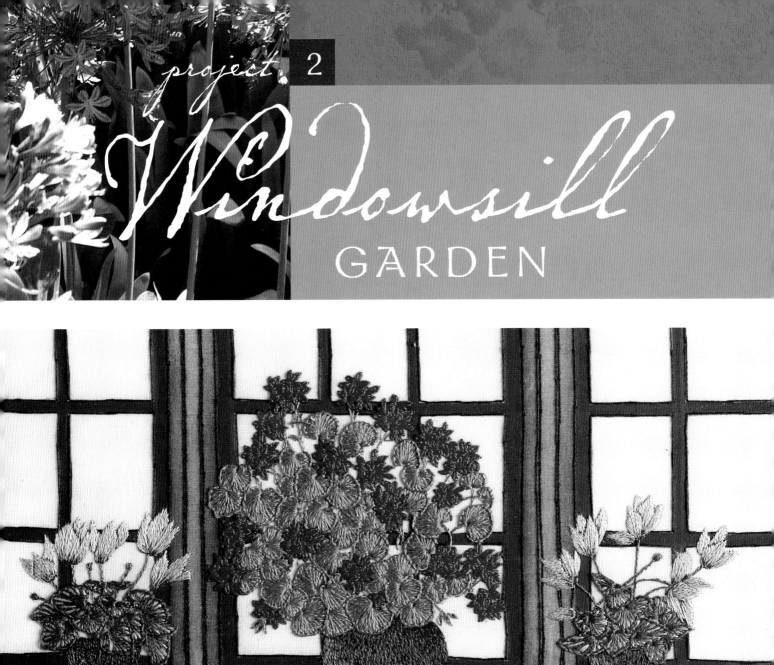

This embroidery of pots of cyclamen and geraniums provides constant cheer in my home during the long cold winter months in Canada.

Summer is a time of transition when I move many of my plants. Some go outdoors; others move away from hot, sunny windowsills and get replaced with ones that love the sun. My indoor garden does not have the wonderful splashes of color that can be found in my outdoor garden. I simply do not have the required light year round, but I do have lots of indoor plants, and enjoy them enormously. I cannot honestly say that the pots of cyclamen and geraniums in this project grow together on my windowsill. Cyclamen like bright light—but never hot sun—while geraniums love the sun. However, this is a piece of art, and the light in this embroidered piece is magically just right for both plants. I hope you get as much enjoyment working through this project as I did creating it.

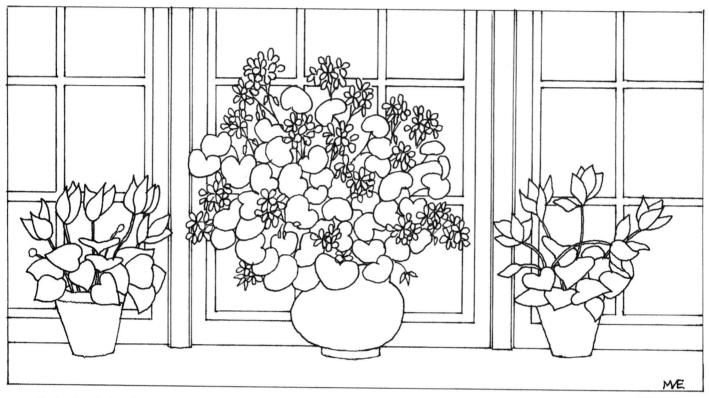

Design for windowsill garden

Design is full size.

Supplies Needed

2 pairs ³/₄"-square softwood stretcher bars:
 1 pair 12" and 1 pair 9" long

Photocopy or tracing of windowsill design

Flat brass tacks (preferably Japan tacks)

Tack remover or flathead screwdriver

15" x 13" prewashed white habotai silk in 10mm or
 12mm weight (Do not iron the silk.)

15" x 13" prewashed white 100% cotton quilting
 fabric for backing

1"–2"-thick book (approximately 8"-10" to fit under
 your frame, used as a hard surface to transfer designs)

Water-based silk paints (such as Pebeo Setasilk) in
 azure blue, cinnamon, silver gray, ebony, hermes red

Opaque paints (such as Pebeo Setacolor) in chamois
 and black

Size 3 (approximately) artist's watercolor paintbrush

¹/₂-oz. plastic gutta applicator bottle with #7 metal nib

Clear water-based gutta (such as Pebeo or Dupont)

Iron

Paint palette

Medicine syringe

Container for water

Small cotton lint-free rags

Hair dryer

12" cork-backed steel ruler

DMC embroidery floss in colors 367, 320, 817, 349,
 3608, 3607, 632, 520, 523, 3371, 300, 301, and 400

Crewel embroidery needles, sizes 8 and 9

Dark brown artist's-quality colored pencil

Sharp pencil

Water-soluble fabric marker (optional)

Quick-grip clamp with 6" opening or c-clamp to attach
 your frame to a table for the embroidery

Tape

Getting Ready

For this project, you will be working with habotai silk.
There are, however, other silks—such as silk satin and
crepe back satin—that would be suitable. You will find
that silk paints flow rapidly on silk, and the results are
more luminous than on cotton.

Be sure to read Stretching Your Fabric for Painting (page 58) and Working With Gutta Resist and Silk Paints (page 59) before beginning.

Creating the Windowpanes

For this project, I have created a window that has no view. I did not want to distract my audience from the focal point of the work, which is the pots of flowers. Instead of a view, I created a mottled effect in the windows by blending a nice soft blue with a hint of cinnamon. This accentuates the warmth of the red and pink flowers. Begin by outlining the window-panes with gutta resist.

APPLY GUTTA RESIST

1. Place your photocopy of the design on top of the 1"–2"-thick book. Then place your stretched fabric on top of that. This provides a firm surface for the gutta application and brings the design directly under-neath your fabric, ensuring good visibility. Make sure your design is centered and straight. Don't worry if it doesn't line up exactly with the grain of the fabric.

2. Using the gutta dispenser, apply a solid gutta line around the 3 main windows, extending the outside frame dimensions by at least $^1/_2$". Ignore the pots of flowers for now, and apply your gutta line directly through them. Try to center your gutta line within what will be your inner dark brown frame. You do not need to apply gutta to the window dividers; they will be painted later. If you have difficulty applying the gutta freehand, use your cork-backed steel ruler, making sure to wipe away any excess gutta that adheres to the underside of your ruler after each application.

3. Finish applying a gutta line $^1/_2$" outside the whole design. You should have 4 enclosed areas: the 3 win-dows and the window frame together with the sill. Make sure your windows are completely enclosed and your gutta lines are solid to prevent the paint from traveling into the rest of the fabric.

Make the gutta outline 1/2" larger than the perimeter of the design. This allows a little extra space to accommodate any errors and for framing.

4. Remove the book and design from underneath, and allow the gutta to dry.

> Never leave your design underneath gutta as it is drying, as the black ink will transfer from your photocopy onto your fabric and can-not be removed.

PAINT THE WINDOWPANES

Silk is very translucent, so it is important to have a white surface underneath your painting to reflect the true colors of your paint. If your work surface is dark, lay a white sheet of paper on your table, then place your frame on top. Never allow the paper or any other object to touch your fabric during the paint process.

> Always test your colors on the edge of your fabric before painting. Remember to dry your paint to get a true sample.

1. Mix 2 colors in your palette. The first color is a combination of azure blue and silver gray diluted with water to the intensity desired. The second color is cinnamon with a tiny amount of hermes red, again diluted to the intensity desired.

2. Using your watercolor brush, wet the window area with water. Blot away the excess moisture with your rag. You want the window to be damp, not soaking.

3. Using your brush, apply blue paint to the windows. Wipe your brush dry; then randomly add 8 to 12 dabs of cinnamon to each window.

4. Rinse and dry your brush; then blend the colors together. Allow the paints to merge on their own for 5 minutes. Add more blue or cinnamon, if needed. Ultimately, you want a nice, soft, mottled effect.

5. Silk paints have a life of their own; when you combine 2 colors within an enclosed area, many changes will occur between the initial application and the dry state. A hair dryer is an essential tool for achieving control with these paints. Once you have achieved the desired results, blow-dry your painting on a low setting to stop any further changes.

The window on the right has just been filled with dabs of paint. The windows to the left of it have been left for 5 minutes, allowing the paints to merge.

Painting the Window Frame and Sill

Now your attention will focus on the external window frame and the windowsill. A light base color is applied overall. A gutta line applied later will divide the frame from the sill, allowing you to paint the window frame a darker shade.

1. In your palette, mix cinnamon, silver gray, and a little ebony. Dilute with water. You are mixing the lightest color of the windowsill. The frame and shadows will be darker.

2. Wet the frame and sill area with your brush and water, absorbing the excess moisture with your rag.

3. Paint the damp area with your mixed color. Allow the paint to partially dry.

4. Transfer a small amount of your base color to another area of your palette. Add a little more ebony. Carefully paint in the shadows of the pots on your windowsill. If the darker paint moves too much, add the base color to push it back. You can also lift color with a dry brush. When you have the results you want, blow-dry the painting on a low setting.

Begin the painting of the sill and frame with a base color.

5. Center your design underneath your painting and tape it in place. Lay your work on top of your book to provide a hard working surface. Carefully apply a gutta line along the bottom edge of your window frame. Apply your gutta line directly through the pots of flowers. Allow the gutta to dry.

6. Remoisten your window frame only, absorbing any excess moisture with a rag.

7. Add more ebony to your base color. It should be twice as dark as your windowsill. Apply this darker color to your window frame. Rinse your brush thoroughly. With a slightly moistened brush, lift some of the darker color from the molding in the center of your frame. This will give your frame dimension and pull the molding forward. Once you are satisfied with the results, completely dry with a hair dryer on a low setting to stop the paint from moving.

8. Remove the fabric from the frame, and permanently heat set it for 3 minutes.

9. Wash the gutta out of your fabric (see page 60, step 8).

Painting the Inner Window Frames and Dividers

Unlike silk paints, which are very fluid and translucent, opaque textile paints have no translucency and stay put when applied to fabric. Very little water is added to the paints—only 1 or 2 drops to achieve a smooth consistency. Opaque paints are great for painting the inner window frames and the window-pane dividers. Use them on dry fabric and then heat set for 1 minute.

1. Before you start painting, restretch your fabric and allow it to dry. Take care to avoid distorting the lines of the windows. Refer to Stretching Your Fabric for Painting (page 58).

2. Hold the frame up to the light, and center your design underneath. Tape the design in place. Lay your frame on top of your book to provide a firm surface for tracing the inner window frame and dividers onto your fabric. You need an accurate outline as a guide for your painting.

3. Using a sharp pencil and a ruler (a quilter's ruler is very useful for this stage, because it is clear and has grid marks), draw the outline of your dark brown inner window frame, making sure that you enclose all the gutta lines. If you find your frame is not straight, readjust your tacks. Draw the pane dividers. Remove the taped design and your book.

4. In your palette, mix the chamois opaque paint with a little bit of black. Dilute with 1 or 2 drops of water. Using a small (size 0–4) paintbrush, carefully paint the inner window frame and dividers, staying within your pencil outlines.

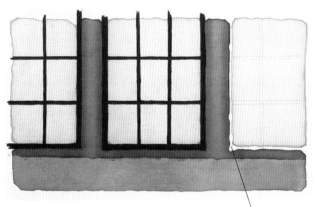

Use a ruler and pencil to carefully outline your frame and dividers, providing you with a guideline for painting them.

The gutta lines are completely enclosed.

Adding Colored Pencil Shading

Colored pencils are very useful tools for detail work. They add character and depth to your painting. Use artist's-quality colored pencils, which have more pigment in the lead. Always test your colors on the edge of your fabric first. Start with a light application, and go darker as needed.

1. When your painting is dry, use a dark brown colored pencil along the base of the frame and the top of the windowsill.

2. If the shadows of your pots are not dark enough or you didn't paint your frame dark enough, use the brown pencil to darken them.

3. You can use the same brown pencil to cover any white areas left over from the gutta lines.

❦ Transferring the Pots of Flowers and Finishing Touches

Before you heat set your opaque paints, take advantage of the translucency of the fabric to pencil trace your pots of flowers.

1. Hold your work up to the light, and center the design underneath. Tape the design in place.

2. Place your book underneath the frame to provide a hard surface. Using a sharp pencil, trace the outline of your pots, the leaves of the geranium and cyclamen, and the cyclamen flowers. Add a few small lines to indicate the position of each geranium flower.

3. Remove the taped design, remove the fabric from the frame, and heat set the fabric for 1 minute on the reverse side.

4. To prepare for the embroidery, stretch your fabric with a backing cloth very carefully to avoid distorting your window frames and dividers (see page 60). It is nearly impossible to prevent all distortions. Use your brown pencil and a ruler to go over the outline of your dark brown inner frame and dividers, effectively straightening your window frame.

❦ Outlining the Window Frame in Embroidery

Outlining your window frame and window dividers in split stitch helps define the window.

1. Using a sharp pencil and a ruler, draw the 2 pieces of molding that are in the center of the window frame. Although you will be stitching 2 lines on either side of each piece of molding, you need draw only 1 line on each side as your guide.

2. Clamp your frame to a table to enable you to use both hands. Using 1 strand of 3371, split stitch the outline of all the frames and the window dividers. Split stitch a row on either side of the lines you drew for the molding. Your stitches should be $1/4$" to $3/8$" long. To ensure smooth results, split through only the very tip of the previous stitch. Avoid stitching the frame and dividers where the flowers and pots overlap them. When in doubt about where your needle should go down, lay down your thread as a guide and then take your stitch.

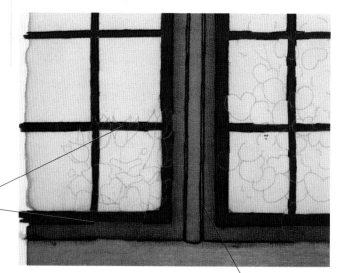

Avoid where the flowers and pots will overlap.

Split stitch the outline of your frame, dividers, and molding.

Draw 1 line, stitch 2 rows.

Embroidering the Flowers and Terra-Cotta Pots

Follow the instructions in the Flower Gallery (pages 6–18) to complete the geraniums and cyclamen. Begin with the flowers, followed by the leaves and stems. Embroider the pots last. Keep the design to guide you.

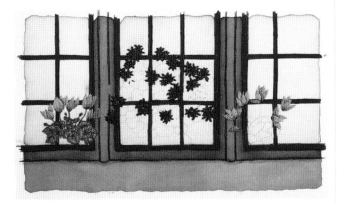

Stitch all the flowers prior to the leaves.

Notice the play of light on the embroidered pots (see photo on page 37). The right side of each pot is shaded, and the left side is highlighted, giving the pots dimension. I use random long and short stitch and three colors of thread to interpret the pots. If you stitch them using only 1 color, they will look flat and lose their rounded shape. If you prefer painted pots instead of terra-cotta, choose 3 consecutive colors to achieve a pleasing transition from light to shade. Before beginning, read Random Long and Short Stitch (pages 55–56) in the Stitch Directory.

1. Draw pencil guidelines on each pot to help you maintain good stitch direction.

2. Use DMC floss 300, 301, and 400 to stitch the pots. Begin each pot by using 1 strand of any of these colors to split stitch along the pot's base. Split stitch the pot's rim if it shows. Be sure to follow the subtle curve at the base that indicates the round shape of each pot. Apply a second line of split stitch to the base of the center pot where the pot changes its shape. The rim of the cyclamen pot on the left will also require 2 lines of split stitch, 1 on the bottom of the rim and 1 on the top of it. The split stitch lines ensure that you achieve nice crisp edges.

3. Thread several needles—1 with 2 strands of 300, 1 with 1 strand of 300 and 1 strand of 400, 1 with 2 strands of 400, 1 with 1 strand of 400 and 1 strand of 301, and 1 with 2 strands of 301. Combining 2 colors in a needle allows for a nice transition of color.

4. Begin at the rim of the cyclamen pot on the left. Using 2 strands of 300, satin stitch over the 2 split stitch lines. Using the same thread, begin your random long and short stitch on the shaded side of your pot. The stitches should vary from $3/16''$ to $1/4''$ in length. Tuck your stitches directly next to the plant leaves. There should be no gaps visible. When you reach the rim of the pot, the stitches should share the same hole as the satin stitch rim. This will make the rim distinct. Use this same satin stitch technique for the base of the center pot, stitching over the lines of split stitch.

5. When stitching the bases of the pots on the left and right, make sure to take your long and short stitches over the split-stitched edge.

6. As the stitching on your pot progresses from shade to light, it is easier if you have all the colors of threads accessible in the work area. Random long and short stitch allows you to work gradually from one side to the other or to work intensely in one area until another area demands attention.

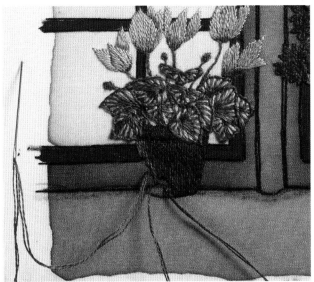

Three threads are at work in the cyclamen pot. It is easier to have them all at hand and bring in each color as it is required.

7. Carefully observe the stitch direction in the geranium pot. This pot is a bit trickier to accomplish because of its round shape. You may want to complete it last.

8. Refer to Lacing Your Embroidery for Framing (page 60) when your stitching is complete.

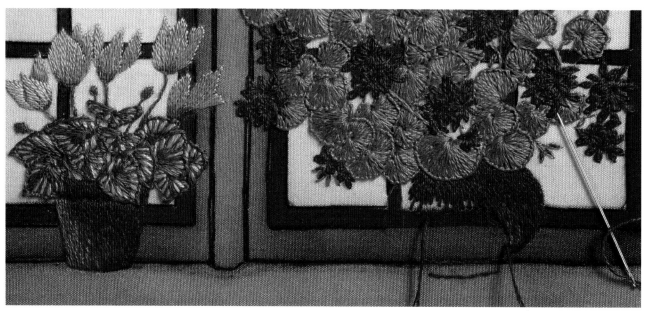

After completing the top of the geranium pot, it is logical to progress along the right side.

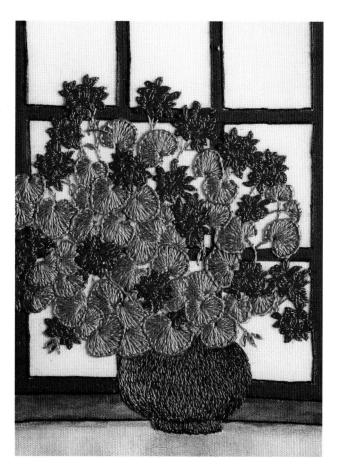

◆ Other Alternatives

The design for this project is only one of many possibilities. You could work from your own window frame design and alter the frame's dimensions and color. Or you could couch down some lace to represent a runner on the windowsill. Instead of potted geraniums and cyclamen, you could stitch pots of pansies or gerbera daisies. A spring window of daffodils and tulips would be very cheery. Another idea would be to embroider a vase of cut flowers. There are endless possibilities. Practice the paint techniques, and learn to master the embroidery. This practice, combined with careful observation of different windows and plants, will allow you to move on to new ideas and to experiment with different images.

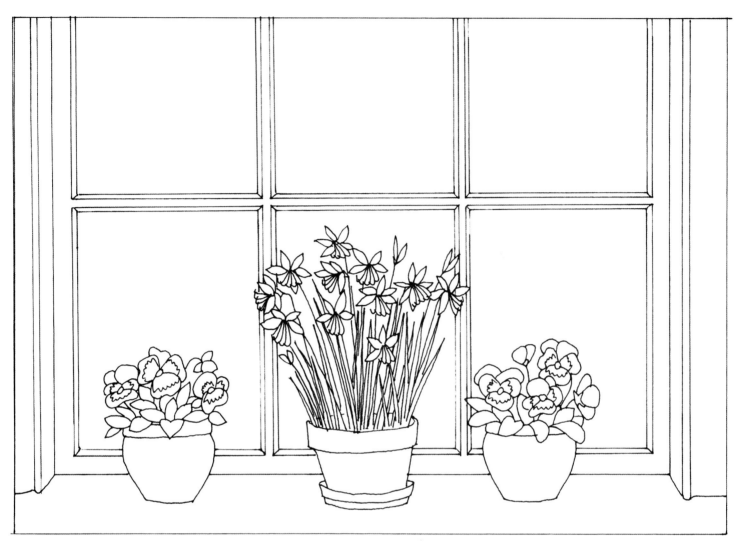

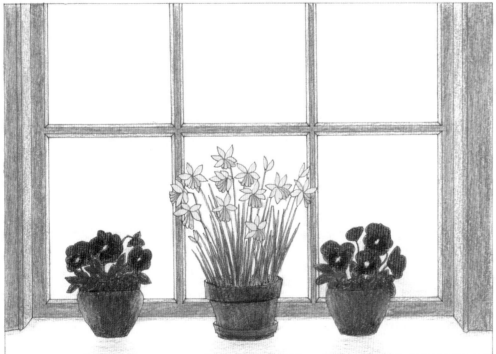

A windowsill garden design with pots of pansies and daffodils to paint and embroider.

Take the time to plan your color scheme. Colored pencils are a quick and easy tool to use. Make several photocopies of your design to experiment with different color combinations and to help you determine the shading on the pots.

There are so many possibilities for indoor window gardens. Here I have painted a soft sky to represent the outside world and introduced some hanging leaves (using Pebeo transparent paints) to create a midground and to enhance the long window. I painted the window dividers in a darker color to contrast with the sky and recede from the rest of the frame. The violet vase is complementary to the sand-colored walls, adding liveliness to the window. I added shadows with opaque paint and colored pencil.

This charming clapboard house, and its garden, uses all the same techniques taught in the projects. Once you have completed a few small gardens, you might like to progress to something more complex like this. When you have stitched many flowers, you will easily be able to interpret your own.

Stitch DIRECTORY

This directory includes all the stitches used in the projects. To better explain the stitches, I have often illustrated them with the needle entering and leaving the fabric in the same motion. However, since your entire project will be stretched taut and stitched on a frame, it is very difficult to accomplish this. You will not be able to insert the needle into and out of the fabric in the same movement. All your stitches have to be worked using a stabbing motion. The needle enters the fabric only from above or below, and never both in the same motion. This maintains good tension in your embroidery.

While working on your embroidery, clamp your frame to a table or embroidery floor stand at all times. This allows you to work freely, with one hand on top of your work and one beneath. Although it may take some time to train your less-skilled hand, ultimately your work will progress much faster.

Starting and Finishing a Thread

Before you begin, it is essential to know how to start and finish a thread. I begin with a granny knot (see below). It is simple to execute and expedient. With a knotted thread, come up from below within the area to be stitched, but not in a hole that will be used repeatedly. Then make a pinhead stitch and proceed to where you want to begin.

To finish a thread, make 2 pinhead stitches in an area that will be covered with embroidery or *between* 2 embroidery stitches so that the pinhead stitches are hidden. After the second stitch, pull your thread up so it creates a tiny mound, and snip the thread with your embroidery scissors directly next to the fabric. I prefer this method over backstitching because it means I don't have to turn my work over.

GRANNY KNOT

Note: If you are left-handed, follow these instructions but reverse the hands specified.

1. Thread your needle by pinching the very end of the thread between the forefinger and thumb of your left hand. Work the eye of the needle between the fingers where the thread is pinched until the needle is threaded.

2. Hold your threaded needle and the last 1/2" of your thread between the thumb and forefinger of your right hand. Your thread should form a circle.

3. Using your left hand, wrap the thread around the needle a couple of times.

4. Hold on to the wraps and the needle with your right thumb and forefinger.

5. Pull the needle through with your left hand, and continue holding firmly to the knot with your right thumb and forefinger.

6. Pull the needle and thread completely through.

7. You should have a knot at the end of your thread. Trim off the tail.

Some Basics

Here are some general terms that I use throughout the book.

Compensating stitch: Used in radial satin stitch and long and short stitch where straight stitches of varying length are applied side by side to fill a shape. The compensating stitch is the shorter stitch that fits between two longer ones, resulting in an increase in the angle of stitching. The length and number of compensating stitches determine the acuteness of the angle increase; the shorter the stitch, the greater the change in angle. Applying two compensating stitches also advances the angle more rapidly.

Couching: Tiny stitches taken at right angles or obliquely to hold down a base thread.

Guiding stitch: Used in radial satin stitch and long and short stitch, especially when there is a large area to cover or when stitching a circular shape. Guiding stitches are straight stitches placed an equal distance apart within a shape. They establish the stitching angle and act as a guide for good stitch direction. After the guiding stitches are applied, each segment is filled in, beginning at one guiding stitch and adjusting the angle of each stitch as you approach the next guiding stitch.

Holding stitch: A small stitch taken at the end of a lazy daisy, buttonhole, or fly stitch to secure the loop.

Pinhead stitch: A tiny stitch, barely discernable, approximately the size of a pinhead. Used when you want to start or end a thread in your embroidery. One pinhead stitch to start and two pinhead stitches to finish will securely keep your embroidery intact.

Seed stitch: A tiny straight stitch applied either directly onto the fabric or superimposed over other embroidery, such as in the center of a flower.

The Stitches

Berry Stitch

See Double Lazy Daisy Stitch (page 50).

Buttonhole Stitch

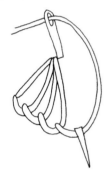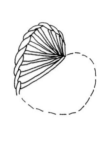

Buttonhole stitch is similar to blanket stitch, but the stitches are worked more closely together. Use this stitch for the round leaves of the geranium, nasturtium, and cyclamen. Begin with a pinhead stitch inside your shape, where the knot will not interfere with your stitching.

1. To start the buttonhole stitch, the needle comes up at A, the heart of the leaf. Hold the thread down with a finger. Then bring your needle down at B, on the outline, and then up at C with the thread catching AB in a loop.

2. Bring your needle down at A again, with a finger and thumb holding the thread taut. Come up at D, which is directly next to C, and again catch the loop.

3. Continue all the way around your leaf until it is complete. As you progress around, it is not essential that the needle always go down exactly at A. It needs to be in or near A.

4. You may need a straight stitch between A and B, which you can apply at the beginning or end to finish the leaf shape.

5. If you have gaps, insert single straight stitches, beginning just inside your buttonhole edge and slipped down to where the threads merge.

6. If you find yourself short of thread part way through a leaf, apply a tiny holding stitch to the last buttonhole stitch. Begin your new thread inside the buttonhole stitch you just finished.

7. Complete the petals in the foreground; then stitch the petals tucked behind. When stitching a background leaf, continue the buttonhole stitch until you reach the overlapping leaf. End your buttonhole stitch, and apply straight stitches from the center of your leaf to the edge of the foreground leaf. When the edge of the background leaf is exposed again, resume your buttonhole stitch.

Buttonhole stitching around a circle is one of the more challenging stitches for my students. Except for the initial stitch, the needle will always go *down* at or near A and come *up* on the outline of your leaf, catching the loop that is held taut. The closer the stitches around the outside, the fewer gaps you will have to fill in later. Create variegated leaves by using a contrasting color to fill in the gaps, which are created intentionally by allowing more space between each buttonhole stitch.

▨ Closed Continuous Fly Stitch
See Fly Stitch (page 51).

▨ Colonial Knot

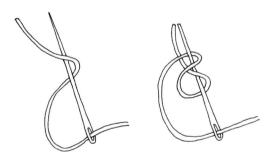

Different from a French knot, a colonial knot is worked in a figure eight and results in a knot that stands up high on the fabric. Use these knots instead of French knots or in combination with them.

1. Bring the thread up in the desired spot, and hold onto it tautly with your left hand.

2. Hook the needle under the thread about 1 1/2" from the entry point.

3. Wrap the thread clockwise around the needle, and enter it close to where the thread emerges, but not in the same hole. Pull all the slack out of the thread, and pull the needle through to the back.

▨ Cross Stitch and Star Stitch

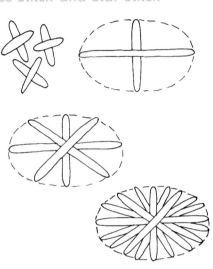

Cross and star stitches are simply straight stitches that cross each other either once or several times. Single crosses are clustered to create the verbena flower. Star crosses form the daisy and chrysanthemum flowers.

1. For star crosses, begin with 4 straight stitches across your circle to form a star pattern that effectively divides the circle into eighths.

2. Once you have placed these first 4 crosses, slip additional straight stitches over and under the point where all the crosses merge in the center. The flower would be too bulky if all petals were crossed. Do not split any threads.

Double Lazy Daisy Stitch or Berry Stitch

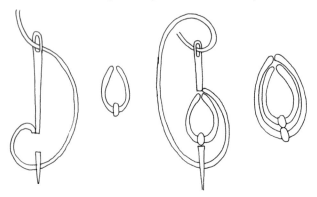

Double lazy daisy stitch is used when a single lazy daisy stitch isn't substantial enough, such as for the petunia leaves.

1. Complete a single lazy daisy stitch first with a small holding stitch.
2. Work a second lazy daisy stitch around the first stitch.

Feather Stitch

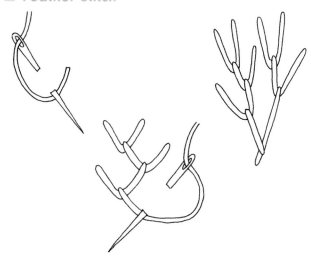

The feather stitch is used for the massed stems and leaves of some plants, such as those of the chrysanthemum and the daisies.

1. Feather stitch begins like a fly stitch (page 51). Instead of applying a straight holding stitch, you create alternating cups, each holding the other in place.
2. Add a longer holding stitch at the end of several feather stitches if you like.

Fishbone Stitch

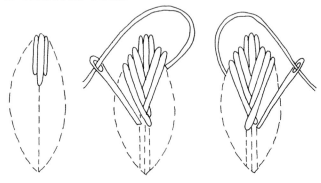

Fishbone stitch is used for the tulip flowers and can also replace satin stitch for the salvia and gerbera daisy leaves. It creates a lovely soft crossover pattern in the middle of each petal.

1. Draw the flowers, or leaves with midrib, on your fabric.
2. Begin with a straight stitch approximately $2/16$" to $3/16$" long at the tip of your shape. Add 2 shorter stitches on either side of the initial stitch.
3. Come up on the left outline of your shape, next to the shorter stitch, and enter the needle just to the right of the midrib line and slightly below the initial stitch.
4. Come up on the right outline of your shape, next to the shorter stitch. Enter the needle just to the left of the midrib line and directly opposite the end of the previous stitch.
5. Continue stitching, alternating sides, all the way down your shape.
6. If your petal is rounded at the bottom, add several satin stitches to finish your shape nicely.

Fishbone Variation

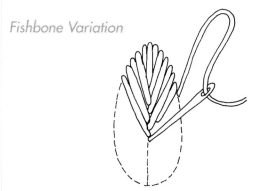

I like to apply a slight variation on the fishbone stitch for my tulips. It has a less raised effect and a softer crossover pattern. Try both methods to see which you prefer.

1. Begin at the tip of the petal with a straight stitch that is approximately ⅓ the length of the petal. Add 2 slightly shorter stitches on each side. Continue to come up on the outline and alternating sides, just as in the fishbone pattern, but instead of crossing over to the left or right of the midrib, each stitch enters *directly* on the midrib and is advanced 1 thread of fabric each time.

2. Because each thread advances, the angle sometimes becomes acute. To correct this, apply a compensating stitch, then resume the same crossover pattern as before.

3. Apply satin stitches to finish off your shape nicely.

Fly Stitch, Open Continuous Fly Stitch, and Closed Continuous Fly Stitch

Fly Stitch

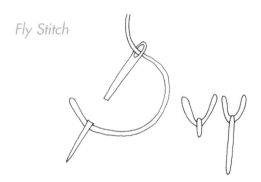

Fly stitch can be used singly to cup around a flower or collectively for feathery leaves, as in the marigold and biden. It is essentially an open lazy daisy stitch. The tail of the fly can vary in length.

1. Bring the needle up through the fabric, and then insert it a short distance away to the right.

2. Bring your needle back up diagonally below, keeping the thread below the needle. Pull the thread through, and fasten with a straight stitch of the desired length.

Open Continuous Fly Stitch

To create an open continuous fly stitch for leaves, begin with a small straight stitch, followed by a fly stitch cupped around it. Continue down the shape of your leaf with more fly stitches. The holding stitch of each subsequent fly begins where the previous fly stitch ended. Sometimes I call this stitch a Y stitch; think of creating a row of perfect Ys.

> The length of your holding stitch determines the openness of your continuous fly.

Closed Continuous Fly Stitch

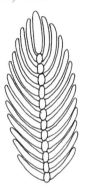

Closed continuous fly stitch is used for larger leaves, such as those of the dahlia. It is comprised of many fly stitches with short holding stitches worked closely together to create a solidly stitched area. You can create nice curves with closed continuous fly.

1. Draw your leaf with the midrib onto the fabric.

2. Begin at the tip of the leaf with a straight stitch that is ⅛" to 3/16" long. Snugly cup around the straight stitch with a fly stitch that has a short holding stitch.

3. Continue with close fly stitches, each new stitch butting next to the previous stitch and following the outline of your leaf. The tail of each fly begins and ends on the midrib line.

> If your fly stitch becomes too flared, you need to increase the length of your holding stitch to regain the nice Y shape.

French Knot

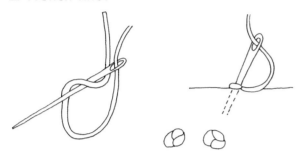

French knots are used to create alyssum, lobelia, and the centers of many flowers. You can combine two colors in the needle to create subtle variations. The size of the knot is determined by the number of strands used or the number of twists; if two twists do not produce a large enough knot, add an extra strand of floss.

1. Come up through the fabric at the spot where you want to make your knot.
2. Wrap your thread clockwise around your needle, approximately 1" to 2" from where your thread exits the fabric.
3. Insert your needle close to where the thread exits, but not in the same hole, and pull on the thread so the knot slides down to the fabric.
4. Push your needle and thread through the fabric, and come up again for the next knot.

Lazy Daisy Stitch

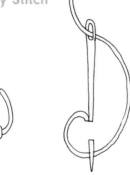

Lazy daisy stitch is used for many of the leaves and flower petals.

1. Bring the needle up through the fabric where you wish to begin the stitch. Hold the thread down with a finger, and insert the needle back into the same hole, or very close to it. If you want a more pointed leaf, enter the needle slightly above the original hole. Then, bring the needle up at the desired distance and inside the loop you are holding down.
2. Fasten down the loop with a small holding stitch. Take care not to pull the loop too tight, or it will close in on itself.

Lazy daisy stitches are effective when clustered in a circle, such as in the geranium. These flowers have more rounded petals, so the lazy daisy always starts in the center of each flower. For more pointed petals, such as the browallia and biden, the lazy daisy is started on the tips of the petals. This stitch can also have a longer holding stitch.

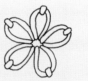 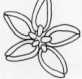

Rounded petals　　**Pointed petals**

Lazy Daisy–Fly Stitch Combination

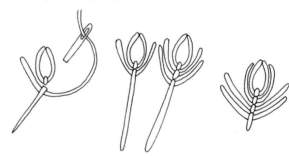

Lazy daisy can be effectively combined with fly stitch to create the flowers of the fuchsia.

1. Begin with a lazy daisy stitch that has a small holding stitch.
2. Cup around the lazy daisy stitch with either an open or a snug fly stitch, depending on what look you are trying to achieve. The fly stitch should be approximately $1/2-3/4$ the length of the lazy daisy stitch.
3. Cup around the first fly with a second fly stitch, or end it with a longer holding stitch.

▣ Long and Short Stitch

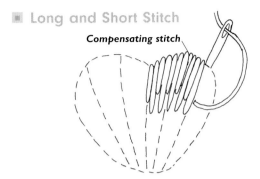

Compensating stitch

Long and short stitch is definitely the most challenging of all surface embroidery stitches to perfect, but the beautiful results are worth the effort. This stitch is used when there is a change in stitch direction, when a color change is desired, or when a shape is too large to complete in radial satin stitch. Pansies, primulas, and petunias are done in long and short. It is helpful to draw your flowers onto your fabric first and lightly draw in some guidelines for stitch direction.

Let's begin with a multiple-petal flower, such as the pansy or primula.

1. Work one petal at a time, always beginning at the center and completing half of the petal's first row and then proceeding to the second half.

2. Bring your needle up inside the petal, and go down on the outline.

3. Alternate long and short stitches, always coming up inside your petal and going down on the outline. The shorter stitches should be approximately $2/3$ to $3/4$ the length of the longer stitches.

4. If you need more dramatic radial stitching, take an additional short stitch or compensating stitch.

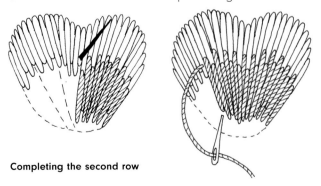

Completing the second row

5. After you complete the first row, start the second row, again beginning in the center and completing half

at a time. For a multicolored flower, this is the obvious place to introduce a second color. For realistic results, direct your stitches toward the center of the flower. The needle should split through the threads of the first row, approximately $1/16''$ to $1/8''$. The bottom of your second row should alternate in length, just as the first row did, either to accommodate a third row or, if you are finishing the inside edge, to allow for the petal converging.

6. As the shape of a petal narrows, you will not split through each stitch of the subsequent row, because there is less space. Try to maintain nice radial stitching throughout. Stitch each petal of the pansy or primula separately; they will be more distinct. If done all at once, you risk having the flower look like the trumpet shape of the petunia.

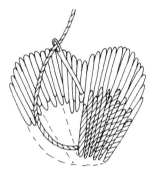

You may find it easier to split into the first row from above rather than from below.

7. Traditionally, long and short stitch is split from below; this helps achieve good stitch direction. You may choose to split through the first row either from below or from above. If you are uncertain about the stitch direction, lay your thread first before piercing the fabric or threads. This helps you find the right place for the needle to enter.

Stitching Circular Shapes

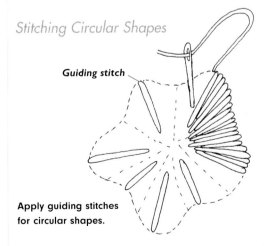

Guiding stitch

Apply guiding stitches for circular shapes.

For petunias, the long and short stitch is worked by first applying guiding stitches.

1. Divide your flower into quarters, then eighths, filling in each section with alternating long and short stitches. In this instance, it is easier to come up on the outline and stitch down toward the center.

2. Because the stitch direction must change with each stitch to attain the circular shape, you may need to apply 2 short stitches for every long stitch. Read the instructions on radial satin stitch to learn how to do this.

> If you find it impossible to produce smooth edges, first outline your shape in split stitch, using very small stitches to achieve a smooth line. Then apply your long and short stitches over this line.

Loop Stitch

Loop stitch is used to create the flower of the tuberous begonia. It is simply a straight stitch that is not completely pulled through from the front to the back of your work.

1. Begin with seed stitch–sized loops in the core of the flower.

2. The loop stitch is most effective if applied in a circular pattern, much like a stem stitch, with the needle coming up inside and halfway back the distance of the previous stitch. Hold down the loop being made to prevent pulling the thread all the way through.

3. Increase the length of your stitch as the flower becomes larger.

4. Continue going around in a circular pattern until your flower is the desired size. Couch down the final row if it is closing on itself.

Open Continuous Fly Stitch

See Fly Stitch (page 51).

Pistil Stitch

Pistil stitch is used for the stamens of the fuchsia. It is a French knot with a tail.

1. Come up through the fabric at the spot where you want the pistol stitch to begin.

2. Wrap your thread clockwise around your needle.

3. After wrapping the needle, insert it into the fabric a short distance from where the thread first emerged.

4. Pull the thread so the knot slides down to the fabric, and push your needle and thread through. If you are using a single strand for stamens, you will need to do a double wrap to have a sufficient knot at the end.

Radial Satin Stitch

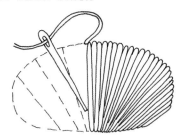

Radial satin stitch is a form of satin stitch in which shorter compensating stitches are sporadically alternated with longer stitches such that the stitching slowly changes direction. This gives the object more dimension and accommodates shapes that come to a point or narrow at either end. Radial stitching is used for the pansy leaves, the nasturtium, cyclamen, and nemesia flowers.

1. First draw all leaves and petals onto your fabric. Lightly draw in some guidelines for stitch direction.

2. Always begin at the center of each shape and work outward, completing half of the flower petal first. Then return to the center to complete the second half. The first stitch should be the entire length of your shape.

3. For the second stitch, bring your needle back up directly next to the top of the first stitch. Slip the needle slightly beneath the first stitch about $2/3$ of the way down.

4. Follow this with a long stitch taken the whole way down that enters the fabric next to the end of the first stitch.

5. Apply a second compensating stitch. Notice how the angle of your stitches gradually changes. You can accentuate the angle by applying 2 compensating stitches, one shorter than the other. The shorter the stitch, the more acutely you change the angle. You must ensure, however, that the compensating stitches are adequately covered when a longer stitch is applied. If it does not cover, the compensating stitches were too short and need to be redone.

> To avoid a wedge shape, do not apply more than 2 compensating stitches at a time before inserting a longer one.

Radial Stitch Variation

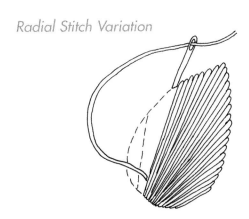

A second method to work radial satin stitch is to initiate the stitching from within the shape and bring the needle down on the outline of the shape, as shown. Choose the method that works best for you. Sometimes I combine both methods.

Random Long and Short Stitch

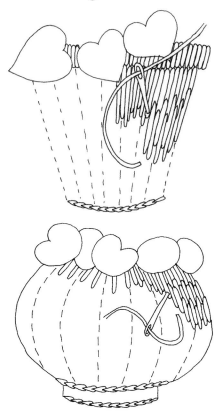

In traditional long and short stitch, the shape is always worked from the outside toward the inside and done row by row. With the exception of a dramatically narrowing shape, the stitches always alternate 1 long with 1 short.

In random long and short stitch, the stitching is more spontaneous. Rather than applying sequenced rows of stitches from top to bottom, I stitch my long and short as I feel it should progress logically. A shape is filled with stitches of varying length and in no exact order. You could stitch 1 long, then 2 short, then a long and a short. The stitches are not uniform in length, thus it is difficult to find actual rows. Rather than working your stitching from the outside toward the center and row by row, you can begin wherever it seems logical and concentrate your efforts in that area until you feel compelled to move to another area. This method is useful for shading. The terra cotta pots in the windowsill project are done in random long and short.

1. Draw your shape onto the fabric. Add pencil guidelines to help you maintain good stitch direction.

2. Split stitch any of the outline that you feel needs a crisp edge, such as the base and rim of the pot. Your random long and short stitching will be done over the split stitch outline.

3. Beginning anywhere at the top of your shape, alternate long and short stitches without adhering to any specific pattern. The more curved your shape is, the shorter your stitches should be to allow for a nice subtle change in direction.

4. Make some guiding stitches to help establish your stitch direction. With the guiding stitches in place, fill in each section with long and short stitches.

5. If you want to develop one side of your shape first, begin stitching beneath your first layer of stitches in that specific area, moving on to the next area as needed. You can choose to split from above or come up from below, or combine both methods. The needle should split into the ends of the first layer of stitches with the needle entering perpendicular to the embroidery.

6. If you are working with multiple colors, you will find it easier to have all of your working threads available in your shape. When a particular color is not in use, bring it to the surface within the shape but away from the area being stitched, and secure the needle to the side of your work. When that color is needed again, make a pinhead stitch, come up in the area in which you are working your embroidery, and continue with your random long and short stitch. You should not travel farther than $3/4$" on the back between stitches. Sometimes you will need to apply 1 or 2 pinhead stitches to get to your destination.

Never leave a needle with thread at the back of your work—it will invariably make a tangled mess.

Satin Stitch

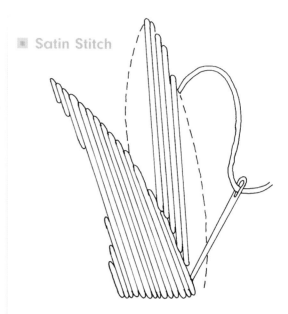

Satin stitch consists of parallel straight stitches worked closely together to fill an area, leaving no material showing. It is used for the tulip leaves and for the base and rim of two of the terra-cotta pots. You will find it easier to obtain a smooth edge if you apply a split stitch outline first, then work your satin stitch over the outline.

1. Bring your needle up on the outline of your shape, beginning at the center of the edge. Enter the needle on the opposite side of the shape.

2. Continue with parallel straight stitches worked closely together, but not overlapping, to fill the area completely.

Satin Stitch Leaf Variation

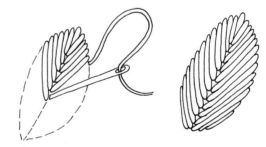

This variation of satin stitch is nice to use for some of the larger leaves, such as those of the salvia.

1. Draw your leaves with midribs onto the fabric.

2. Begin with a small straight stitch, about $1/4$" in length, at the tip of your leaf.

3. Make 2 stitches on either side of the first straight stitch with the needle, coming up on the outline of the leaf and entering the midrib line slightly below the first stitch.

4. Continue alternating sides, coming up on the outline of your leaf and entering the needle on the midrib, slightly below the previous pair of stitches. Each pair of stitches shares the same central hole.

5. You can increase the slant of your stitches by slightly increasing the distance on the midrib line between each pair of stitches, but be careful not to leave gaps.

6. You might need to add a couple of short satin stitches that do not extend to the midrib on either side of the leaf to finish off the shape nicely.

■ Split Stitch

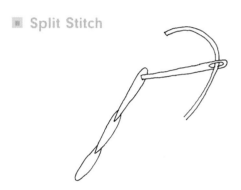

Split stitch is used for many of the stems. It is a simple stitch that allows you to create graceful curved stems and branches; it can also be used prior to applying long and short stitch to achieve a nice crisp edge. I prefer to split the thread of the previous stitch from above, where it is readily visible, rather than search for it from below.

1. Begin with a small straight stitch along the line to be worked.

2. Advance forward a short distance along your line, and bring the needle through to the front.

3. Enter the needle into the tip of the previous stitch. The needle should be perpendicular to the thread upon entry or at an angle that goes with the direction of the stitches.

4. Continue moving forward, coming up further along your line and splitting the previous stitch from above.

The length of your stitches is largely dependent on the curve of your working line. If you have a tight curve, the stitches should be shorter. If your working line is relatively straight, you can increase the length of the stitch.

■ Star Stitch

See Cross Stitch (page 49).

■ Stem Stitch

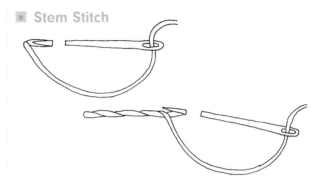

Stem stitch is often used to create the stems of flowers.

1. To begin, come up from underneath, and make a small stitch from left to right. Come back up in your original hole.

2. Make your second stitch twice the length of your first. Then come back halfway and up through the same hole made by the first stitch. Keep your thread below your needle.

3. Continue stitching from left to right, always coming back up through the hole made by the previous stitch and keeping your thread below your needle at all times.

4. Keep your stitches small, especially when stitching tight curves.

For a wider stem stitch, rather than reentering the same hole on your backstitch, come up beside the previous stitch.

Wider stem stitch

Techniques

Stretching Your Fabric for Painting

When you are working with silk paints on fabric, it is imperative that your fabric be stretched taut on a frame. For the projects in this book, you will stretch your fabric a minimum of 2 times. When stretched, the material becomes a smooth suspended surface, able to take the dye evenly. If your fabric is in contact with another surface, the paint will pool and dry unevenly.

There are many types of frames and tacks on the market. It is nearly impossible to insert tacks into hardwood frames without destroying half your package of tacks. It is worth splurging just a little to purchase nice softwood frames and sharp Japan tacks from an embroidery supply shop. It will be worth every extra penny you spend, especially on the frames.

Purchase frames that are $^3/_4''$ x $^3/_4''$ by the lengths needed for your project. If you are handy, you can make your own frames, using a soft wood such as pine. See page 62 for a list of suppliers.

1. Put your $^3/_4''$-square frame bars together. When assembled, your inside frame size should always be at least $1^1/_2''$ larger than your design on all sides. (Add 3" to your dimensions.) For ease of stretching, cut your fabric approximately $1^1/_2''$ larger than the outside frame size. (Add 3" to the outside frame dimensions.)

Cotton and habotai silk rip beautifully along the grain with a small initial snip at the selvage.

2. If you are using silk, mist it first with tap water from a plant mister. Make sure the entire fabric gets damp, or you will have watermarks. The silk only needs to be damp, not soaking wet. Because silk stretches more when it is damp, you will be able to stretch it more tightly on the frame. The misting also prevents the fine silk fibers from being damaged when you pierce it with tacks.

3. Position your fabric with the warp—your lengthwise grain—running vertically (the warp always has less stretch than the weft). Tack *one side* at a time. Place a tack in a corner, then pull down *very tightly* on your fabric to tack the second corner of the same side. Make sure you have an equal fabric margin at each end. Tack in the middle, and then continue to subdivide the areas until you have tacks placed at $^3/_4''$ to 1" intervals.

4. Stretch the fabric tightly to the *opposite* side, beginning in the middle. Make sure you keep your weave parallel to the frame. Complete each half, working from the middle out to the corner, pulling the fabric tight before inserting each tack. Once this opposite side is complete, you can proceed to complete the third side, which you pull minimally. Finish with the fourth side, which you pull *taut*.

5. If any tiny puckers occur along the way, simply remove those tacks and adjust.

Pull the fabric very taut before inserting a tack.

Working With Gutta Resist and Silk Paints

I like to use Pebeo Setasilk paints, which are water-based and nontoxic and become permanent with iron fixing. Although alcohol-based paints give a beautiful, even finish, they are toxic and require steam fixing. Silk paints are very fluid and will keep moving when applied to fabric, unless a barrier is created to contain them. For all the projects in this book, gutta resist is used to retain the silk paints.

Important: All painting is done with your work in a horizontal position. Never paint with your frame in a vertical position; gravity will cause the paints to leak over the gutta barrier.

1. Before you begin painting, apply gutta resist to outline the areas where you want the paint contained, such as the outer edge of the windowpane and the wall outside the window. Use clear, water-based gutta for this. The best applicator for gutta is a 1/2-oz. plastic applicator bottle with a #7 metal tip. This applicator ensures clean, fine lines with no accidental blobs, as often happens with the disposable tubes. You can easily transfer the gutta from a disposable tube to a good applicator bottle. The best ruler to use is a cork-backed steel one. The cork slightly raises the ruler off the fabric, easing the gutta

application and ensuring that the ruler won't slip. Wipe the gutta off the back of the ruler each time you lift it from the fabric.

2. Your gutta nib should touch the fabric and be at a 45° angle. Apply firm, even pressure. If any part of your line is broken, apply additional gutta for an effective barrier. Allow the gutta to dry completely. Gutta takes a couple of hours to air dry. You can speed the process by using a hair dryer on a *low setting* (to prevent moving the gutta) until it is dry to the touch, then continue drying on your hot setting.

3. Never leave your design underneath gutta as it is drying, because the black ink will transfer from your drawing onto your fabric and cannot be removed.

4. You can achieve excellent, smooth results with water-based silk paints if you lightly dampen your fabric prior to applying the paints. This is easily done by using a watercolor artist's paintbrush and tap water to moisten the area to be painted. To achieve maximum paint penetration, absorb all excess moisture with a lint-free cotton rag. Old pajamas and T-shirts make great small rags.

5. Fill a jar or similar container with tap water for rinsing your brush between colors. Always use a rag to absorb excess moisture from your brush.

6. Setasilk paints are so fluid that they act more like a dye when applied to fabric. The colors are very concentrated; dilute them with tap water to the color intensity desired. The paler you want a color, the more water you add. Always test your colors first on the edge of your silk and dry with a hair dryer. *Keep in mind that silk paints are always darker when wet.* Be sure nothing is touching your fabric when you are painting, or your finish will not be smooth.

A medicine syringe, available at any pharmacy, is a great tool for drawing up water and controlling the amount you add to your paint.

7. Once your fabric painting is completely dry, remove the fabric from the frame and heat set it to make the colors permanent. I place my painted fabric between 2 pieces of cotton to avoid any possible transfer of paint or gutta to the iron or ironing board. The cotton will also protect your painting if your iron is exceptionally hot. Use a dry iron on a hot setting, and iron for 3 minutes, moving the iron slowly over the entire painting.

8. To wash out the gutta, soak the fabric in hot soapy water for at least 15 minutes. You might need to help it along by rubbing the gutta off the immersed fabric with your fingers. When all of the gutta is removed, rinse your fabric several times. Place the fabric flat on a towel, and place another towel on top. Pat gently to absorb the excess moisture.

Stretching Your Fabric for Embroidery

The procedure for stretching your fabric for embroidery is similar to that used to stretch it for painting. The main difference is that you will be using a second layer of 100% cotton quilting fabric for a backing. There are many reasons for doing this. First, it gives the piece greater strength when you are stitching, especially if it will be heavily embroidered. Second, it hides any dark carrying threads on the back that might appear through light-colored backgrounds. Third, it eliminates the translucency of the fabric and reveals the true color of your painted background. Finally, it protects the embroidered fabric from ripping when it is stretched for framing. I like to use quilting cotton because the weave of the fabric is not too tight.

1. To stretch both layers, cut a piece of cotton fabric the same size as your painted fabric. Tack them together simultaneously. Make sure that the directional grain of each fabric matches. It doesn't matter if your painted fabric is still damp from washing out the gutta. It is essential to stretch your fabric *very taut* in the frame; it should be tight as a drum. If your painting has rows of painted bricks or a painted window frame, take special care in stretching to ensure the image doesn't get distorted.

2. Place tacks every $1/2$" to $3/4$". Complete your top first, then pull the middle of the bottom tight. (See Steps 3–5, Stretching Your Fabric for Painting, page 58)

3. When everything looks good, hammer your tacks down to ensure that they stay in place. This also prevents your flosses from snagging on the tacks. If puckers develop at any time during the embroidery, this means your fabric was not stretched tightly enough. Remove the tacks (you may only need to do one side) and restretch.

Preparing Your Embroidery for Framing

Many embroiderers are content to have a reputable framing shop stretch their embroidery. However, I have taken apart many very poorly stretched pieces of work: puckered, stretched crookedly, glued or stapled to non-acid-free backings. Lacing your work is not difficult, and this method is expedient.

SUPPLIES NEEDED

$1/8$" pressboard OR acid-free foam-core board
Aluminum foil, if you are using pressboard
Inexpensive acid-free paper
Tape
2 large-eyed needles (darning or chenille needles)
Lacing thread (strong thread that will not stretch: mercerized cotton, butcher's twine, dental floss, or DMC #5 perle cotton also work well)

LACING YOUR EMBROIDERY FOR FRAMING

1. Determine the size of board to cut. If you intend to mat your embroidery, allow at least 1" extra on each

side of your design. For example, if your embroidered design measures 8" x 14", cut the board 10" x 16". This additional area will be enough for any size mat that you choose. If you do not plan to mat your work, cut your board the exact size, plus the recess in the frame. This can vary, but $1/4"$ is standard, which means adding $1/2"$ to your dimensions.

2. Wrap the pressboard with a single layer of aluminum foil. Pressboard is very acidic and requires a barrier between it and your work. Since foil is inert and inexpensive, it acts as a good barrier.

3. Lay a sheet of acid-free paper, cut to size, on top and bottom for additional protection. If your embroidery is not backed, to a piece of cotton the same size as your embroidered fabric to stretch it with. When an embroidery piece is not backed, extreme caution must be taken when lacing; the tension from pulling can easily cause the fabric to rip.

4. Center your embroidery right side up over the covered board. Allow a margin of fabric at least $1^1/2"$ on all sides. Trim fabric if necessary.

5. Carefully turn your embroidery over onto a clean surface, face down with the board on top. Fold the 2 sides in to the center. Use 4 small pieces of tape to tack in place. Turn the piece over to check alignment

6. Cut a long length of lacing thread, and thread each end onto a darning needle. (For the projects in this book, use a 14' to 16' length.)

7. Beginning at the top right side, take a horizontal stitch toward the center with one of the needles. Pull through half of your lacing thread. With the second needle, beginning at the top left side, again take a second stitch directed toward the center. Pull all of your thread through to get relatively even lengths on both sides.

Take stitches opposite each other and directed toward the center.

8. Continue to lace your embroidery in corset fashion, crossing the threads and taking a stitch on opposite sides with each needle, always directing the stitches toward the center. Keep stitches $3/4"$ apart. Alternate sides throughout, and keep your stitches opposite each other. If you run out of thread, knot on an extra length close to where you exited the fabric. Put both threads together to achieve a secure knot.

9. When you have finished lacing, return to the top and grasp the first 2 threads before they cross. Pull tightly toward the center. Continue down, grabbing the threads at the top of the cross and pulling tightly toward the center each time. When finished, tie off your ends with a couple of secure knots.

Pull the lacing taut and tie off the ends.

10. Fold in the other 2 sides, slightly tucking in the edges at the corners. Secure with 4 small pieces of tape. Repeat the lacing process on these sides, and tie both ends with secure knots.

Tuck in the fabric at the corners.

If your lacing thread breaks midway, switch to a stronger and possibly thicker thread.

Suppliers

Canada

Mrs. Twitchett's Eye
1739 Pembina Hwy.
Winnipeg, Manitoba R3T 2G6
Phone/fax: 204-261-7747
Email: twitchet@mb.sympatico.ca
Website: www.mrstwitchett.mb.ca
General embroidery supplies (stretcher bars, Japan tacks, needles, DMC floss)

G&S Dye
250 Dundas St. West, Unit 8
Toronto, Ontario M5T 2Z5
Phone: 1-800-596-0550
Fax: 416-596-0493
Email: info@gsdye.com
Website: www.gsdye.com
Silks, Pebeo gutta resist and applicators, Pebeo Setasilk paints, Pebeo opaque paints

Sureway Trading Enterprises
555 Richmond St. West, #507
Toronto, Ontario M5V 3B1
Phone: 416-596-1887
Fax: 416-603-8366
Email: surewaytdg@aol.com
Silks, Dupont gutta resist

Loomis and Toles
Locations throughout Canada
254 St. Catherine St. E.
Montréal, Québec H2X 1L4
Phone: 800-363-0318
Fax: 800-565-1413
Website: www.loomisartstore.com
Pebeo setasilk paints and Pebeo opaque paints, Prisma-colored pencils, Pebeo gutta resist in tubes, tracing paper

Books for You
RR 1
Edwards
Ontario, K0A 1V0
Phone and fax: 1-800-282-4502
Email: booksforyou@ottawa.com
Website: www.booksforyou.com
Excellent selection of embroidery books

Julee's Homecrafts
5502 Main St.
Osgoode, Ontario K0A 2W0
Phone: 613-826-1243
Fax: 613-826-1343
Email: julees@sympatico.ca
Website: www.julees.ca
Aleene's Fabric Stiffener and Draping Liquid, quilting fabrics and supplies

United States

Dharma Trading Co.
P.O. Box 150916
San Rafael, CA 94915
Phone: 800-542-5227
Fax: 415-456-8747
Email: info@dharmatrading.com
Website: www.dharmatrading.com
Silks, gutta resist and applicators, Pebeo Setasilk paints, Pebeo opaque paints, silk tacks

Nordic Needle
1314 Gateway Dr. S.W.
Fargo, ND 58103
Phone: 800-433-4321
Email: info@nordicneedle.com
Website: www.nordicneedle.com
General embroidery supplies (Japan tacks, stretcher bars, needles, DMC floss)

Michaels Arts and Crafts Stores
throughout Canada and the United States
Website: www.michaels.com
Search for store locator
DMC flosses

Bibliography

Baker Montano, Judith, *Floral Stitches*, C&T Publishing: Lafayette, CA, 2000.

Better Homes and Gardens Complete Guide to Gardening, Meredith Corporation: Des Moines, IA, 1979.

Bird, Richard, *50 Recipes for Colourful Window Boxes*, Ward Lock: London, 1997.

Clabburn, Pamela, *The Needleworker's Dictionary*, Macmillan: London, 1976.

Francini, Audrey A., *Crewel Embroidery with Texture and Thread Variation*, Van Nostrand Reinhold Publishing: London, 1979.

The Gardener's Encyclopedia of Plants and Flowers, Dorling Kindersley Publishers: London, 1989.

Hewlett-Packard Company, with Cyndy Lyle Rymer, *Photo Fun*, C&T Publishing: Lafayette, CA, 2004.

Holt, Alison, *Flowers and Plants in Machine Embroidery*, Batsford: London, 1990.

Lampe, Diana, *Embroidery From the Garden*, Sally Milner Publishing: Burra Creek, New South Wales, Australia, 1997.

Martin, Tovah, *Taylor's Weekend Gardening Guides: Window Boxes*, Houghton Miffin: Boston, 1997.

Nicholas, Jane, *Stumpwork Embroidery, Designs and Projects*, Sally Milner Publisher: Burra Creek, New South Wales, Australia, 1998.

Stevens, Helen M., *Embroidered Flowers*, Trafalgar Square Publishing: North Pomfret, VT, 2000.

Tamura, Shuji, *The Techniques of Japanese Embroidery*, Krause Publications: Iola, WI, 1999.

Wilson, Erica, *Crewel Embroidery*, Charles Scribner's Sons: New York, 1962.

Index

About the Author

Margaret Vant Erve spent her youth jumping from hay wagons with her four siblings and showing calves at the local fall fair near Ottawa, Canada. She nurtured an early interest in drawing the animals, flowers, and scenery of her rural farm environment.

Margaret continued to draw and eventually studied art at Sheridan College and the Ontario College of Art in Toronto. While in Toronto, she also began her studies in embroidery. Eventually, her fine arts and embroidery training merged to create a unique style of textile art that combined fabric painting and embroidery.

Margaret lives in Ottawa with her husband, two daughters, and her border collie. She takes advantage of the easy access to the countryside and surrounding small communities to find inspiration for her wild and domestic floral creations. She also enjoys teaching, which allows her to inspire students to come up with their own designs and discover their own innercreativity. Margaret's work is held in many private collections across North America.

 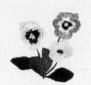 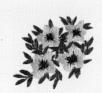 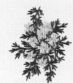